THE

BOOK
of the
BIRD

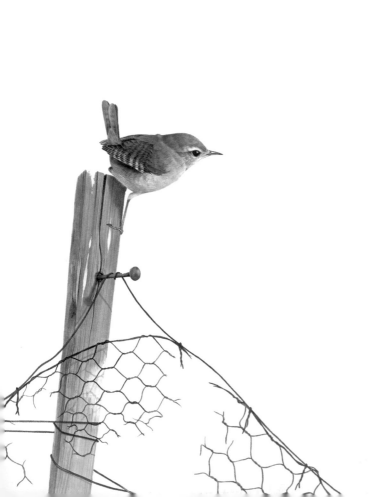

THE
BOOK
of the
BIRD

Birds in Art

ANGUS HYLAND
& KENDRA WILSON

LAURENCE KING PUBLISHING

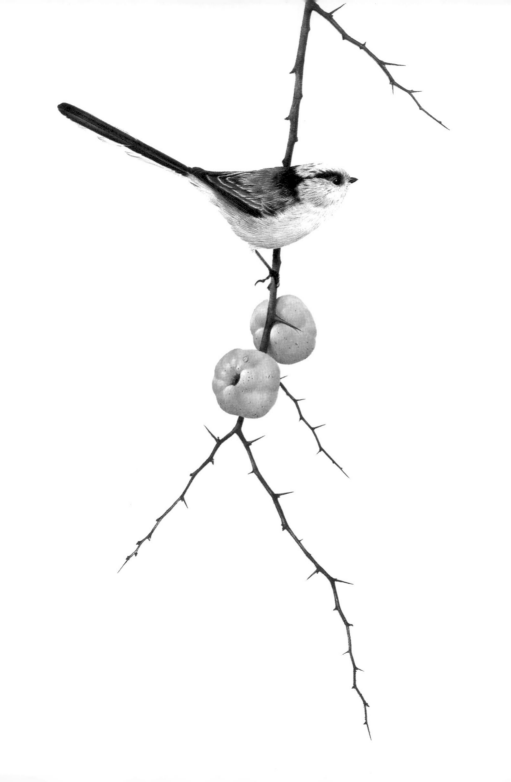

The divide between ornithologists and the rest of us is wide. Our knowledge is faltering, the swallows' arrival in spring less likely to be recorded on the potting shed wall. We need artists to evoke birds, not only in order to appreciate their life-enhancing qualities, but to keep them going. Birds remind us that there is a food chain, and some of them are higher up than we are.

Bird symbolism, if not knowledge, is as powerful as ever. The gift of flight enables birds to travel between worlds, the dove crossing a flooded earth, clutching an olive branch (or twig) in its beak, the raven an ambassador from Hades. Birds of the night attract even more attention: owls are portents of death, when they are not standing in for wisdom and intuition.

Eggs, nests, feathers, birdsong: the trappings of bird life have always intrigued. Yet it is their gift of flight which has inspired our imaginations to really take off. Leonardo da Vinci's technical drawings of engineered and natural wings reveal the genius of the man as well as the bird. Frustrated attempts at flying came with a respect for the original model: he made a habit of buying birds in cages in order to set them free.

There is a romance about bird life which is irresistibly attractive to artists, as well as an otherness. Breaking out of an egg must be hard enough without the prospect of jumping off the edge of a nest. When the bird transforms from a starving, featherless bag of bones into something altogether more beautiful and accomplished, it is put in a cage, or shot, or eaten by any number of things – including other birds.

The Book of the Bird brings together all these facets of the avian world: knowledge and superstition, air and earth, wilderness and domesticity, hunters and songbirds.

KW/AH

Frontispiece: Terence Lambert, *Wren*, 1976
Left: Terence Lambert, *Long-Tailed Tit and Quince*, 1976

EDGAR DEGAS

Young Woman with Ibis

————————— 1860–62 —————————

In terms of ornithology, *Young Woman with Ibis* is pure fantasy. The birds' beaks are lacking the downward curve of the species, and the bright-feathered Scarlet Ibis is native to South America and the Caribbean. Yet the landscape here indicates North Africa. In Egypt, the African Sacred Ibis was venerated as a symbol of the god Thoth, often depicted as half-bird, half-man, writing on papyrus.

The birds here reflect a fascination with orientalism, which had particular currency among the Impressionists in the second half of the nineteenth century. The sketchiness of the birds, along with the hands and face of the woman, is striking. Far more detailed attention has been paid to the folds of the woman's shroud, which recalls Degas's admiration for Ingres during this early period.

There is a symmetry here: the two birds centring the dreamy girl, the flowers complementing the pale background. As in Japanese prints, the spatial pattern is decorative over naturalistic.

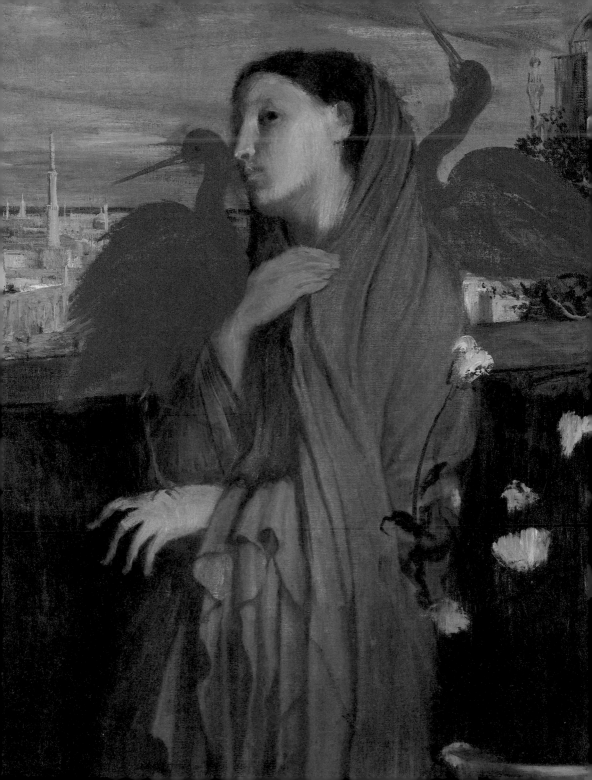

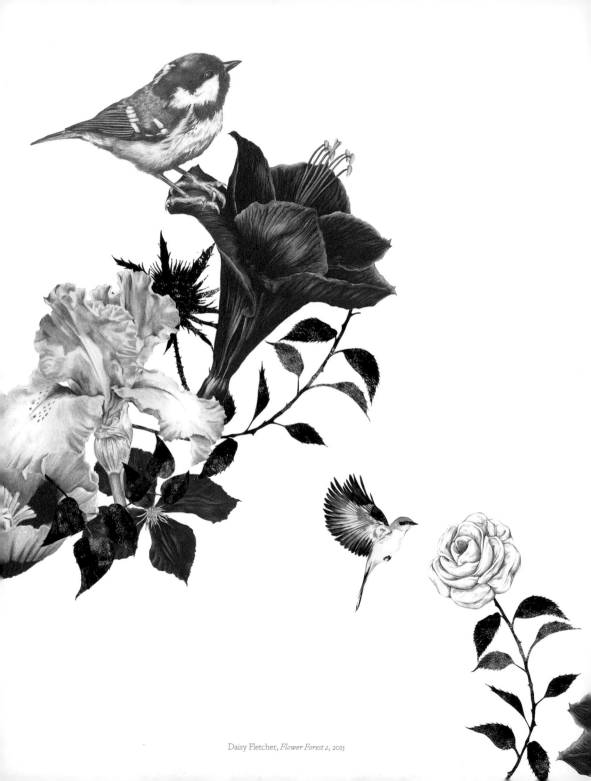

Daisy Fletcher, *Flower Forest 2*, 2015

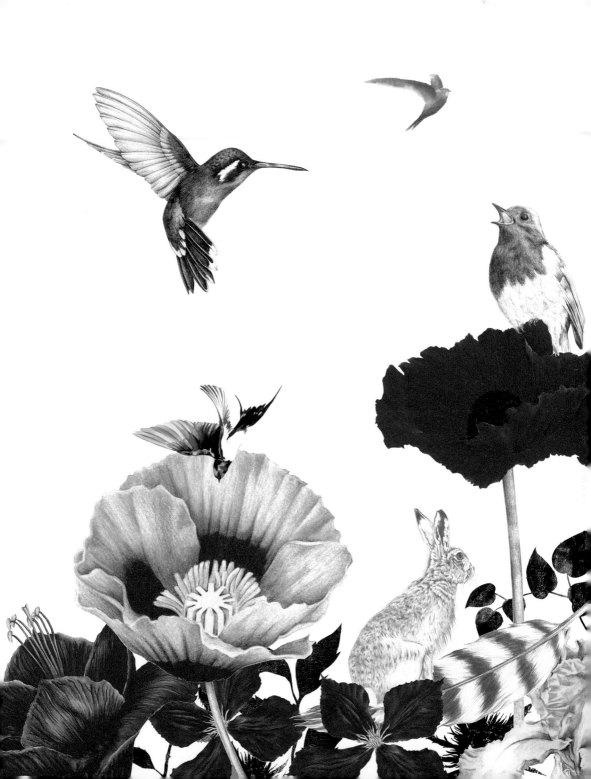

Above and right: Sarah Esteje, *Watercolour Bird 1* and *2*, 2012

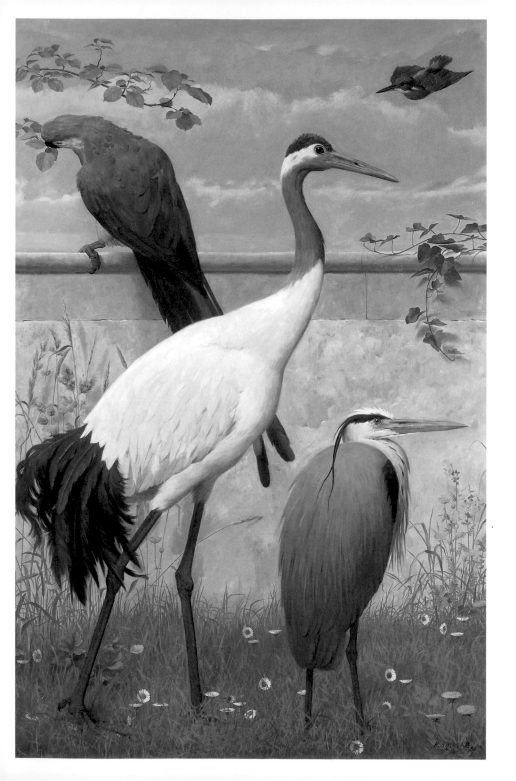

HENRY STACY MARKS

Manchurian Crane, Common Heron,
Blue and Orange Macaw and a Kingfisher

------------------------------ **1870s** ------------------------------

With his formal compositions, often of exotic birds and mainly in profile, Henry Stacy Marks was well placed to work on the frieze around the outside of London's Royal Albert Hall. He also dabbled in theatre design and wrote a column for *The Spectator*. His show 'Birds in Bond Street' was a precursor to his joining the Royal Academy.

Marks (or Marco to his many friends) was a member of the St John's Wood Clique, whose focus was on painting historical set pieces. He was also partial to London Zoo, sometimes accompanied on drawing trips there by his friend John Ruskin. A lightness of touch in both life and art ensured that Marks was popular and busy.

Clearly, though, he preferred the company of birds, and the people in his bird paintings take second place. He added a humour which undermined the formal arrangements, the parrot here reminiscent of an errant model in a photographic portrait. One element which is distinctly unphotographic is the kingfisher, gliding along in slow motion. You'd never see that in the blink of an eye.

THE

grey heron

FEEDS ITS YOUNG BY

CARRYING FISH

IN ITS

GULLET

The menu is enhanced
with frogs, snakes and
smaller waterfowl

Above: Matt Adrian, *A Sudden Point of Convergence*, 2012
Right: Ohara Koson, *Egrets in Snow*, 1927

Unpromising surroundings
do not deter the

pied
wagtails

THEIR

bobbing
tail feathers

cheer up car parks
everywhere

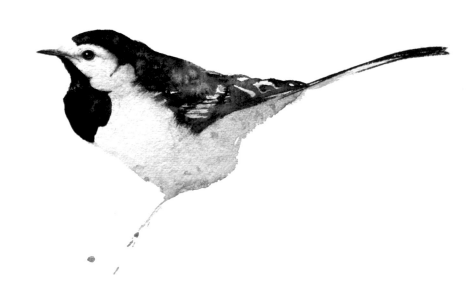

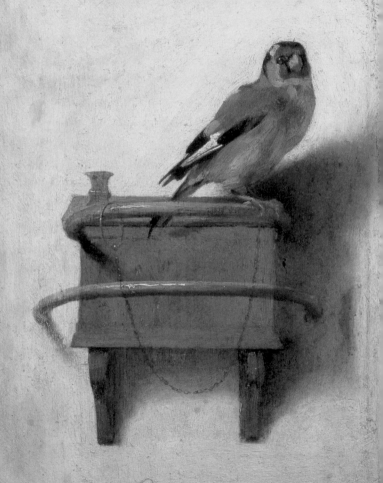

CAREL FABRITIUS

The Goldfinch

1654

Before it found fame on the cover of Donna Tartt's 2013 novel *The Goldfinch*, this life-sized bird had its own tale to tell. The small painted panel was the work of Carel Fabritius, protégé of Rembrandt and lesser-known master of the Delft School. More often a footnote to Vermeer (whom he influenced) than the subject of scrutiny himself, Fabritius died in 1654, at the age of 32, the year that he painted the little pet bird. The artist was killed in an explosion at the Delft arsenal that wrecked a quarter of the city, along with Fabritius's studio and most of his work.

In Tartt's novel, Fabritius's goldfinch hangs at the Metropolitan Museum of Art in New York. It is being admired by a young boy and his mother before a bomb blast kills the woman, and the boy grabs the painting. Explosions mark its passage but the painting itself is a masterpiece of trompe l'oeil, intended to be hung high. Seen from a slight distance, the bird and feeding box appear to be three-dimensional, standing out against the flat plastered wall. It is only on closer scrutiny that the bird becomes a two-dimensional painting, defined by broad brushstrokes.

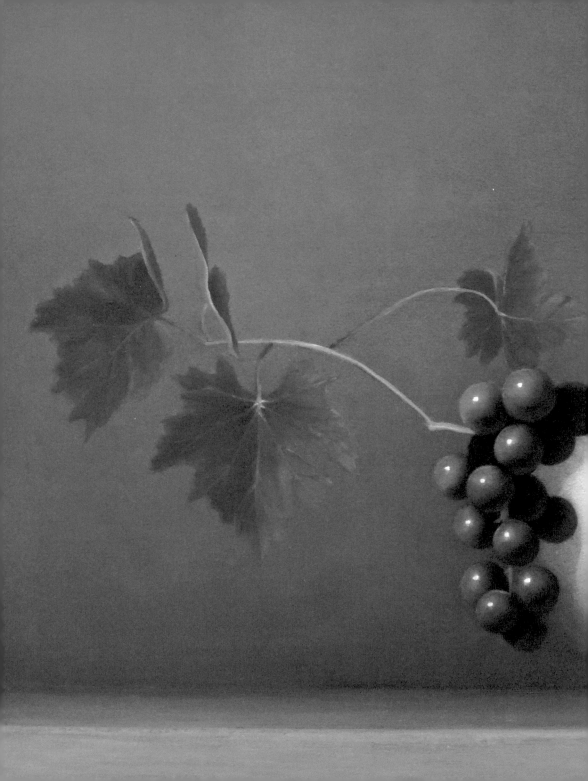

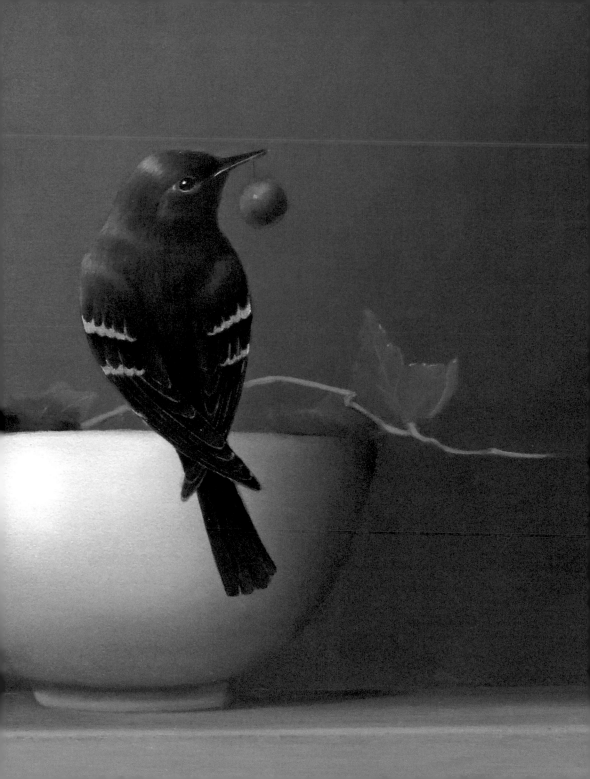

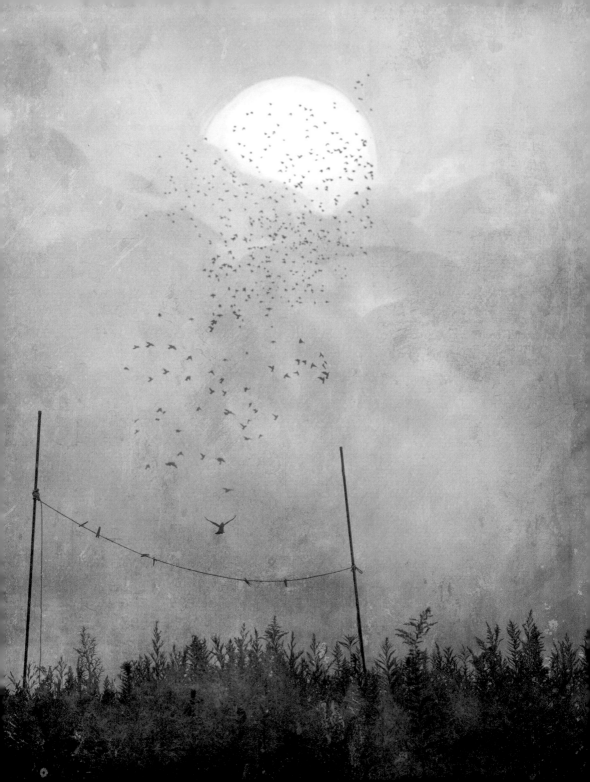

Previous spread: Sarah Siltala, *Night Visit*, 2014
Left: Jamie Heiden, *End of the Line*, 2013
Above: Jamie Heiden, *She Had Wings On*, 2015

THE

blue pinyon jay

LIKES A BERRY
BUT MAINLY RELIES ON

PINE NUTS

It buries them underground,
ensuring renewed life
for the pine tree in
the American West

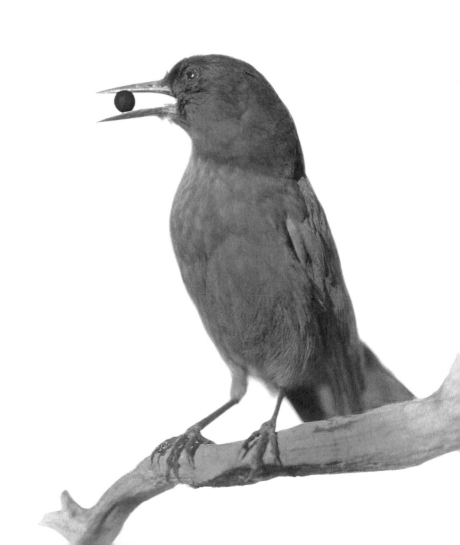

CRAIGIE AITCHISON

Yellow Painting

When Craigie Aitchison was at the Slade School of Art in London in the 1950s, opinions of his work were as divided as they are today. One tutor, the painter L. S. Lowry, was in favour, while another, John Piper, was not. Yet Aitchison never struggled commercially and his popularity continues unabated since his death in 2009.

Aitchison was more interested in the Italian Quattrocento than the Kitchen Sink School. His ethereal landscapes and boldly pretty colours set him apart in the post-war scene, with what his first dealer Helen Lessore called his 'Mediterranean talent'. Aitchison had discovered the clear light of Italy as a student, entranced by painters of the Renaissance period and earlier. He later divided his time between Tuscany and Peckham.

Crucifixes were a constant in Aitchison's painting and so were animals, often sharing the same sparse canvas. As well as his own Bedlington terriers, he had a tendency toward birds, often yellow or set against yellow. Aitchison kept loose canaries in his sitting room, where they used stuffing from his sofa for their nests.

WHEN HATS WERE
MORE POPULAR,
SO WERE

swallows

with their irresistible feathers.

SOMETIMES A WHOLE BIRD
WAS USED TO MAKE
A SINGLE HAT, LIKE

FLYING
HEADGEAR

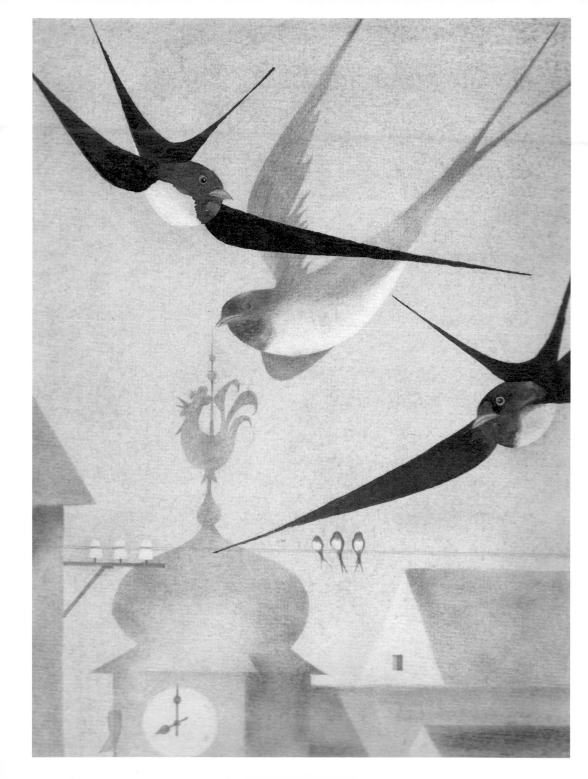

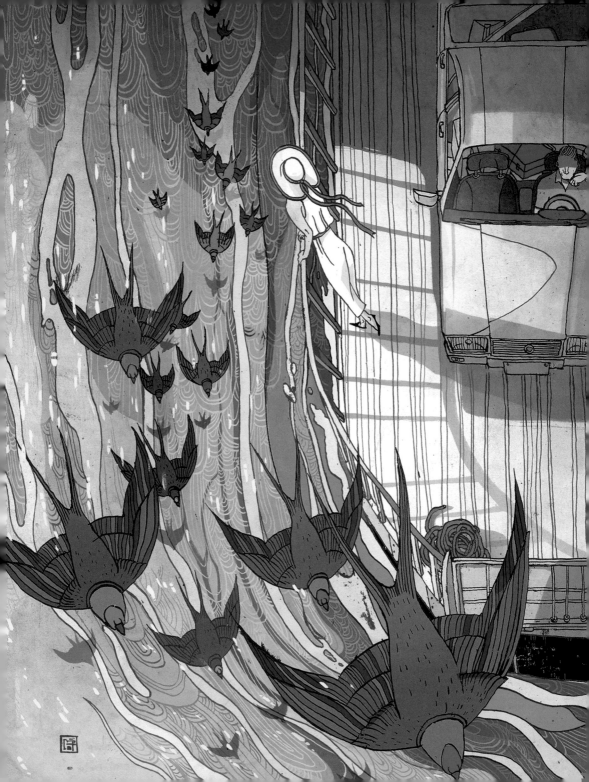

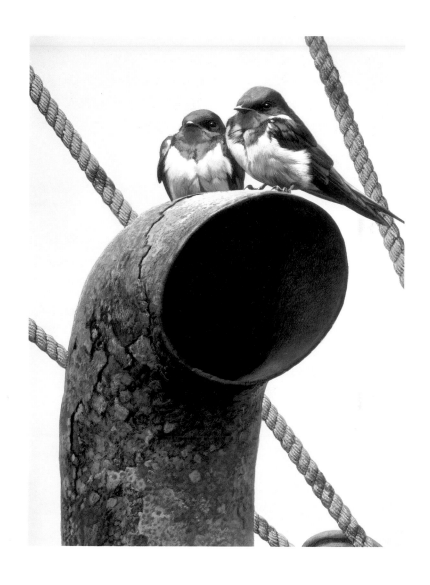

Left: Victo Ngai, *Casserole*, 2013
Above: Carl Brenders, *The Stowaways - Young Barn Swallows*, 1988

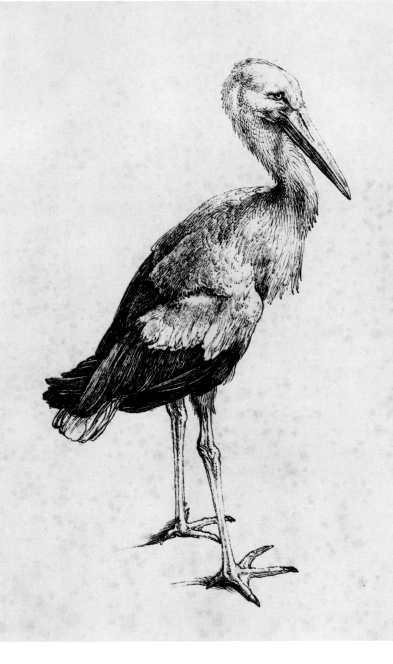

ALBRECHT DÜRER

The Stork

1515

Albrecht Dürer was a generation younger than Leonardo da Vinci but has been considered his German equal. With his insatiable artistic and scientific curiosity, Dürer led his own Northern Renaissance. After extensive trips to Italy, he brought back the latest ideas on perspective and proportion. Dürer's studies in anatomy informed his religious artwork, but his animal studies, like the much-reproduced *Young Hare*, were masterpieces in their own right.

Dürer's work remained popular in Germany (as well as Italy) after his death in 1528, leading to a movement known as the Dürer Renaissance. Its leading exponent, Hans Hoffman, specialized in nature studies which were homages to Dürer: the master's *Great Piece of Turf* was repackaged as Hoffman's *Small Piece of Turf*.

The appeal of Dürer's stork is in its artless pose, standing with the patience of a life model. This 500-year-old stork has vitality. Like the iconic hare, it appears to have been drawn from life; the question of taxidermy is a moot point.

Daisy Fletcher, *Tree Life*, 2007

Becci Maryanne, *Stork*, 2010

NATURALIST
JOHN JAMES AUDUBON
FILED THEM UNDER

'Songsters'

in his lifework,
The Birds of America.

Other common ground is
their preference for

BEETLES

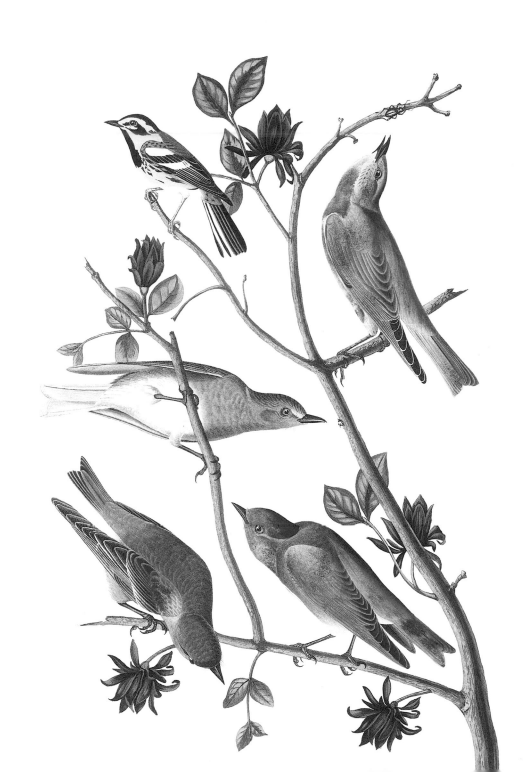

Above: Jan Wilczur, *Phoenicircus nigricollis*, 2004
Right: (top) Brian Small, *Lobotos oriolinus*, 2005;
(bottom) John Cox, *Melanopareia maranonica*, 2003

Angela Moulton, *Flying Warbler*, 14 August 2015; *Cerulean Warbler No. 42*, 20 November 2014;
Bluebird No. 38, 5 September 2015; *Red-Tailed Hawk*, 19 November 2014;
Blue Titbird No. 29, 17 December 2014; *Another Baby Killdeer No. 9*, 10 June 2014

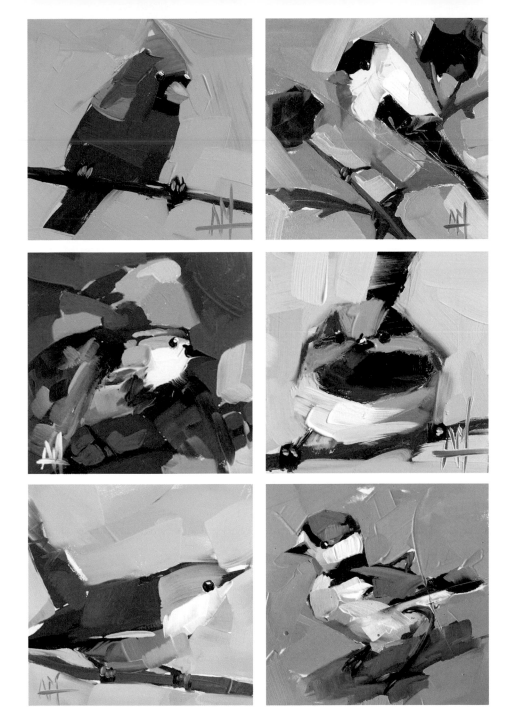

Angela Moulton, *Cardinal No. 152*, 25 May 2015; *Goldfinch and Purple Thistle*, 3 August 2014;
Nebraska Western, 5 May 2015; *Fairy Wren*, 29 July 2015;
Carolina Wren No. 35, 19 June 2014; *Baby Killdeer No. 8*, 9 June 2014

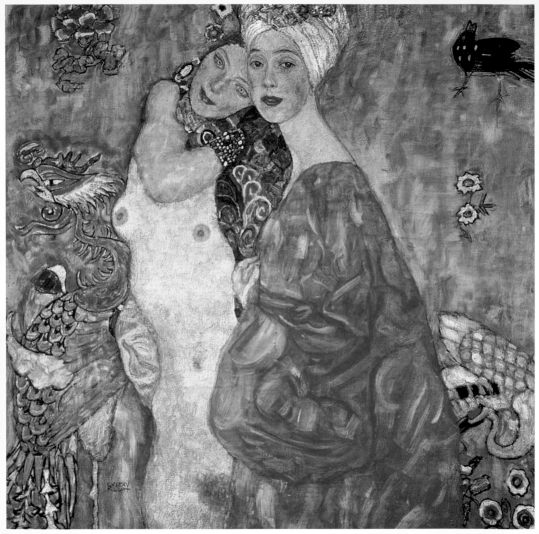

GUSTAVE KLIMT

The Girlfriends

This painting was blown up by the SS in 1945, but not because the subject matter was deemed 'degenerate', like so many artworks that failed to reach the peculiar moral standards of the Third Reich. The artist, whose work had been dismissed as 'pornographic' in his lifetime, met with Hitler's approval. Gustave Klimt had painted the *Beethoven Frieze*, for example, and Beethoven's Ninth was one of Hitler's favourites. Never mind that the painting featured naked Gorgons and a diabolical gorilla.

Klimt used orientalism in his work, along with anything else that took his fancy, including fashion. Swathed in opulent fabrics swirling into a chinoiserie of exotic feathered creatures, the women in *The Girlfriends* are as cheerful as the chirping bird in the corner. Blackbirds are rich with symbolism; a singing blackbird in particular is an Old Testament invitation to 'temptations of the flesh'.

The Nazis stored a collection of stolen Klimts in Castle Immendorf, Austria. When it was clear that the war was lost, SS officers placed explosives in its towers and all of the artworks inside went up in smoke, including the joyous girlfriends shown here.

Above: Broncia Koller-Pinell, *Silvia Koller with Bird-Cage*, 1907-8
Right: John Frederick Lewis, *Caged Doves, Cairo*, 1864

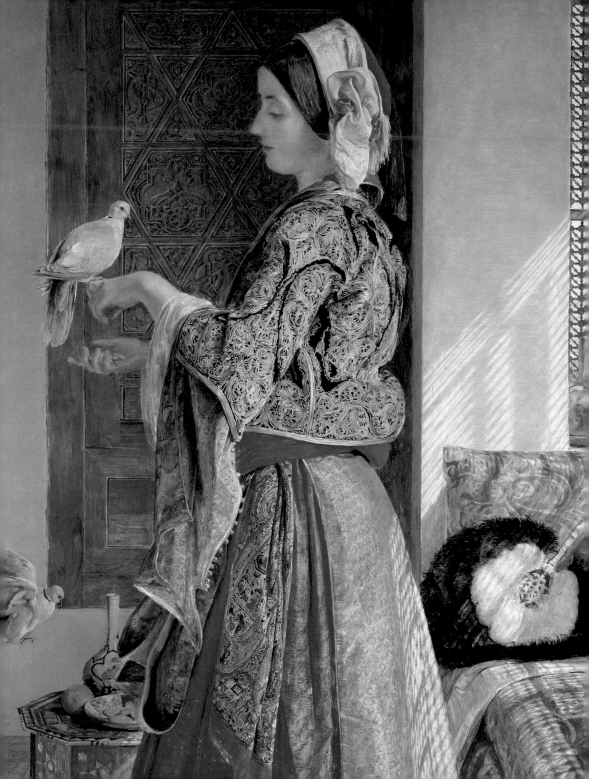

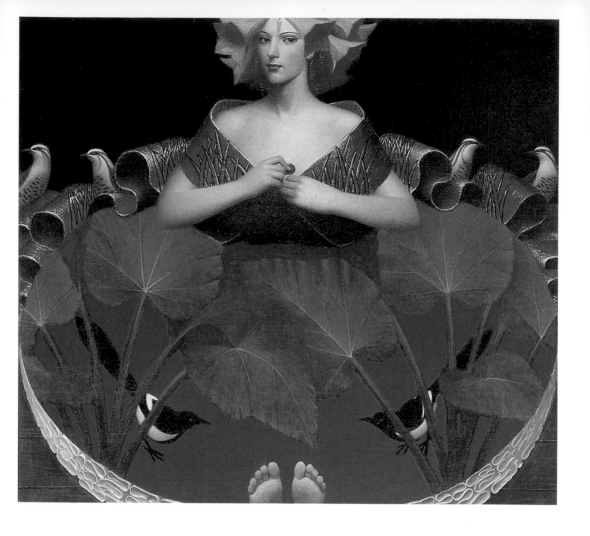

Andrey Remnev, *Hotbed*, 2014

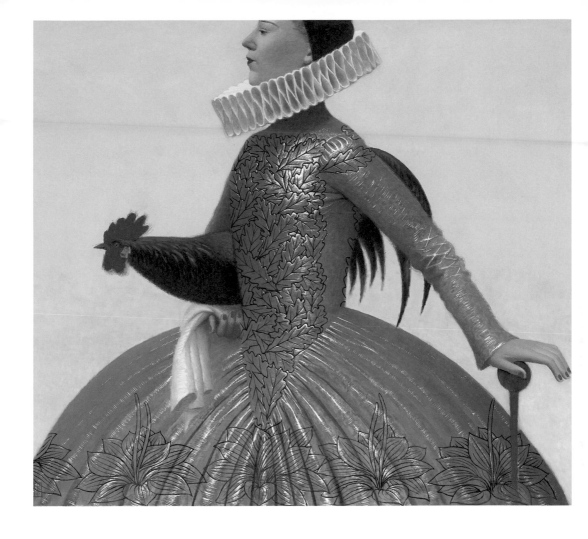

Andrey Remnev, *Terra Vigilia*, 2014

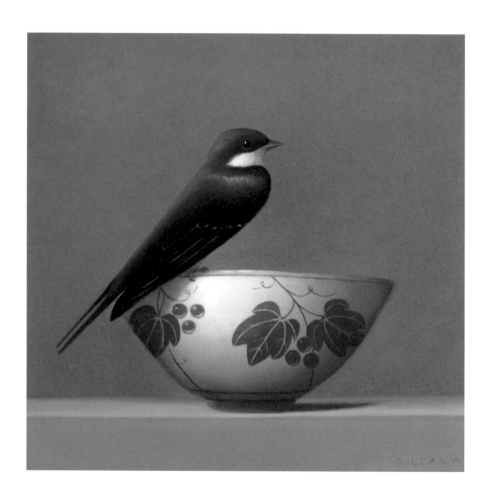

Above: Sarah Siltala, *Swallow*, 2014
Right: Sarah Siltala, *Four Cherries and a Swallow*, 2015

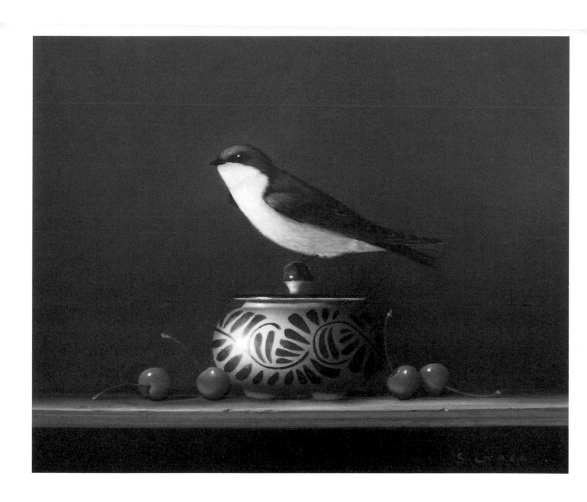

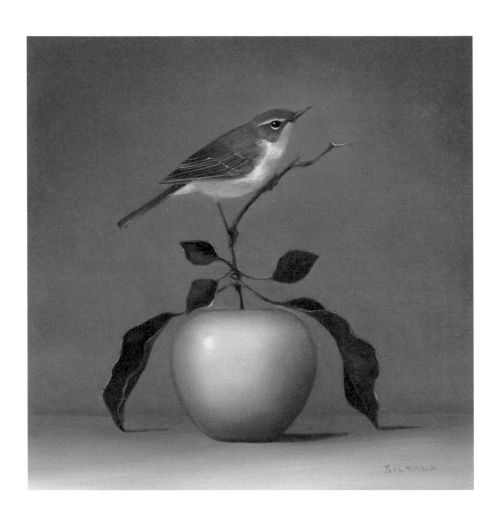

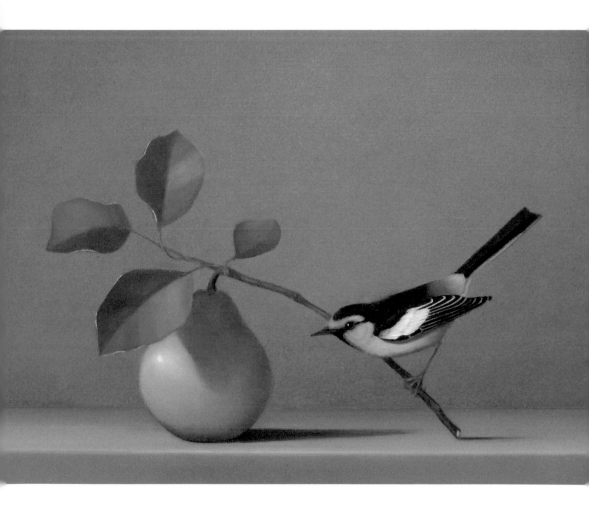

Left: Sarah Siltala, *Perch on a Golden Apple*, 2014
Above: Sarah Siltala, *Pear and Oriole*, 2014
Following spread: Kai and Sunny, *Migration South*, 2013

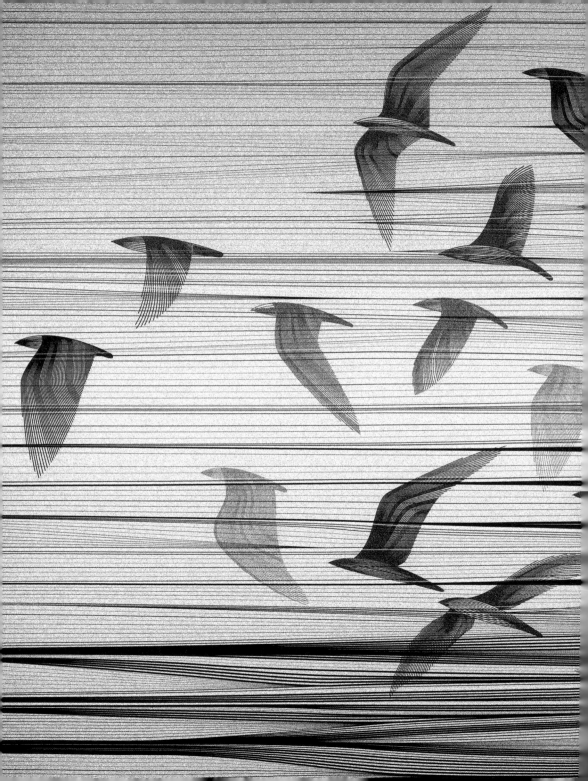

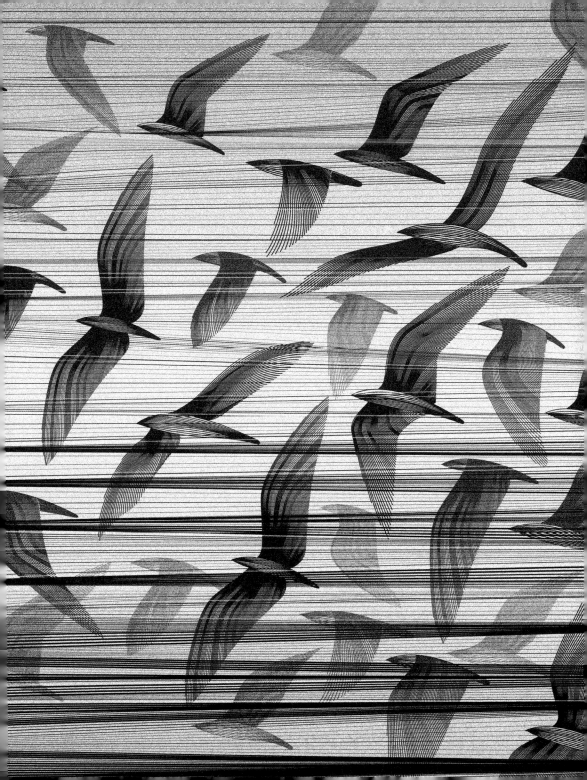

RAVENS

ARE THE
DARK COUSINS
OF

MAGPIES

AND

JAYS

They are all
noisy members
of the crow family

Karl Mårtens, *Raven*, 2012

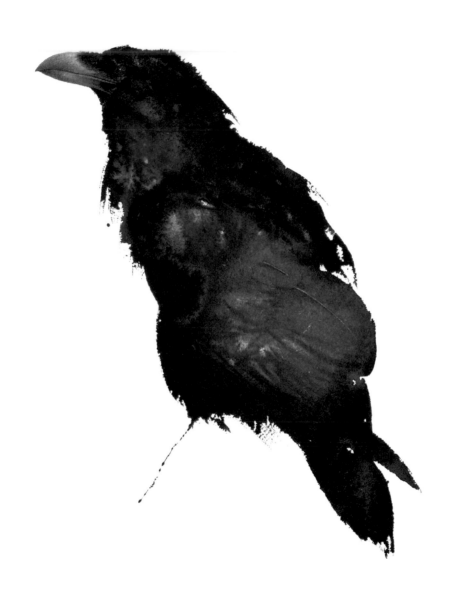

Juliette Bates, *Silhouette*, 2011

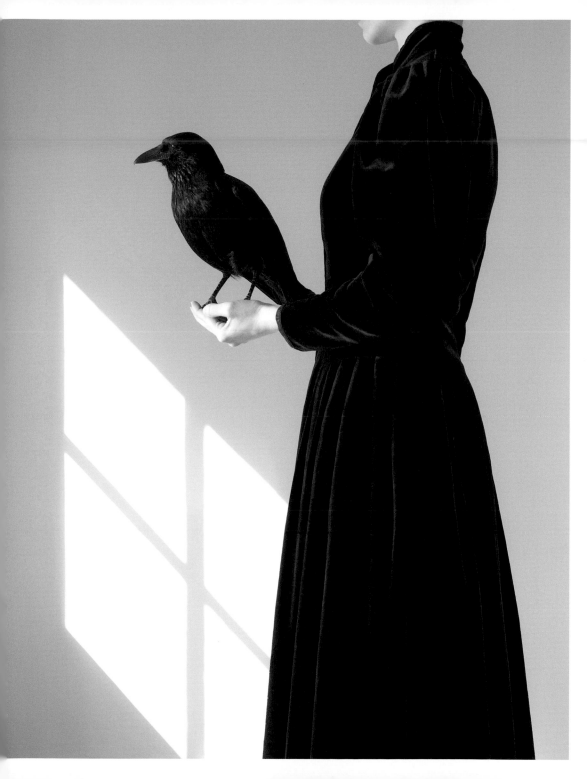

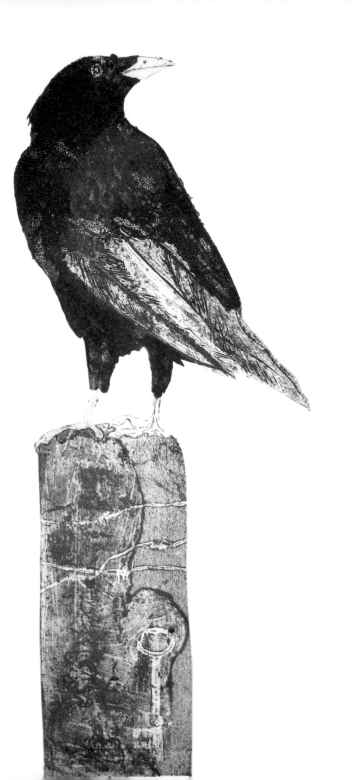

Left: Sue Brown, *Watching*, 2010
Above: Dušan Vojnov, *Raven and the Rose*, 2001

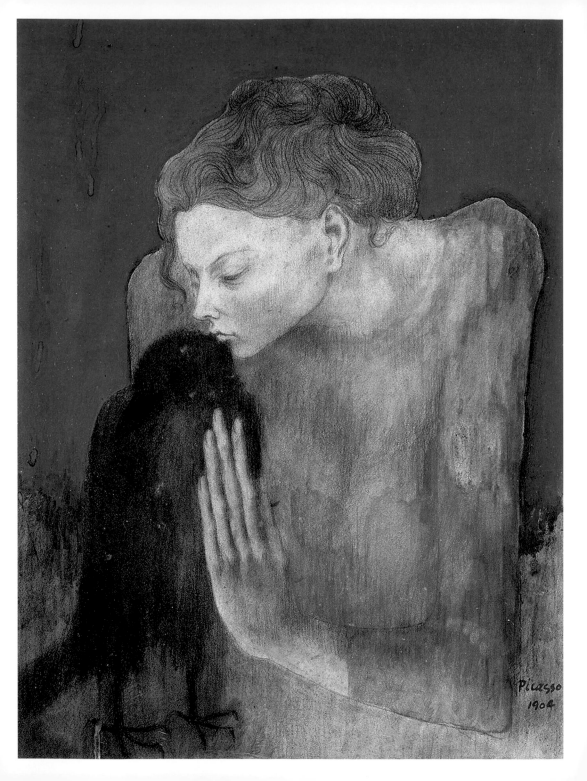

PABLO PICASSO

Woman with a Crow

She could be a customer at Le Lapin Agile, Picasso's favourite bar during his early Paris years. But this is not a portrait of an absinthe drinker; the devotion on the girl's face tells a different story. Though the object of her affection is rather peculiar, a striking tenderness passes from human to bird.

Painted in 1904 at the end of Picasso's Blue Period, there is evidence here of Rose, Blue's successor. The pastel background with its infused colour is offset by more detailed gouache for the figures, with warm tones that are absent in the earlier blue-on-blue paintings. The young woman, 'Margot' (Marguerite Luc, stepdaughter of the owner of Le Lapin Agile), still bears the gaunt and elongated signature of the Blue Period, but there is blood running through her veins.

Like black cats, crows are thought to bring bad as well as good luck. This one, with its cat-like claws, seems happy just to be made a fuss of.

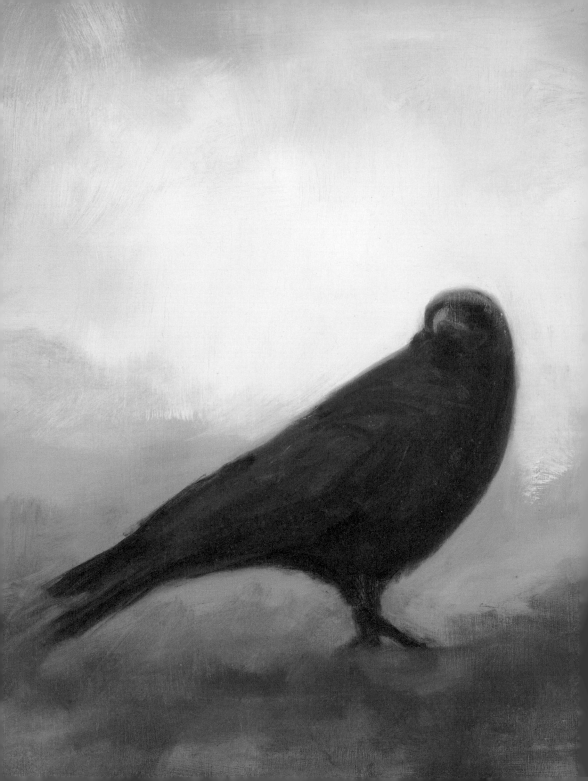

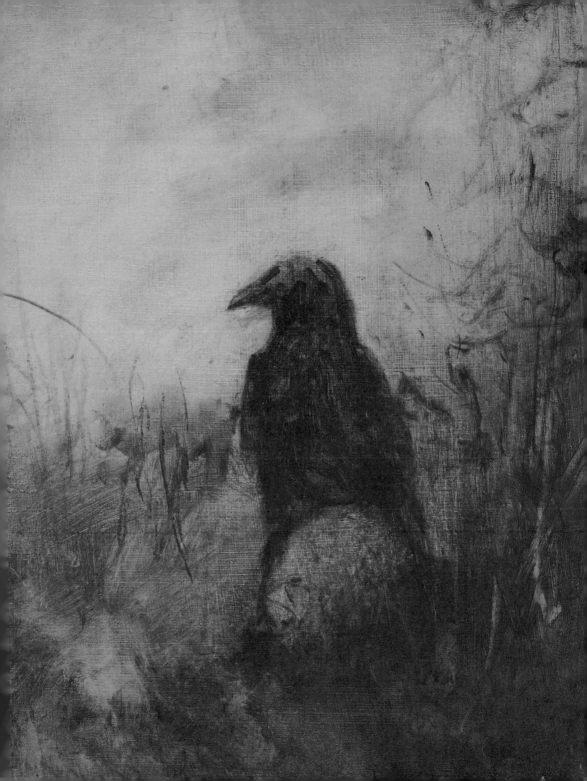

Previous spread: David Ladmore, *Crow #24* and *Crow #7*, 2008
Above: David Wilcox, *The Traveler*, 2012

WE CALL A FLOCK
OF CROWS A

'murder'

DESPITE THEIR RENOWNED
SENSE OF HUMOUR

Sakai Hoitsu after Ogata Kōrin, *Crows in the Moonlight*, early 19th century

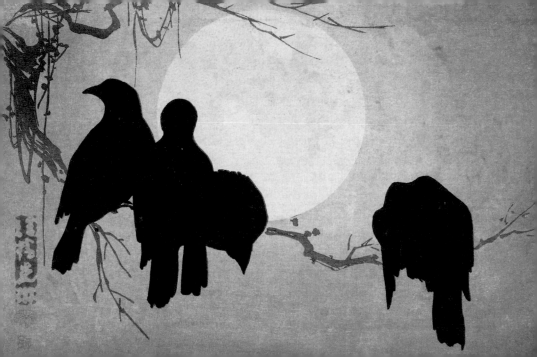

ANDREY REMNEV

High Water

Born in 1962, the year of the Cuban Missile Crisis, Andrey Remnev grew up thinking about Russia's pre-revolutionary past. The view from his window was very Breugel, he has said, and his art apprenticeship was spent copying three centuries of paintings at a monastery museum in Moscow.

Remnev cites the influence of the World of Art painters, who thrived on a nostalgic escapism during the first two decades of the twentieth century. He also admires Constructivism, which embraced current events post-1919 while remaining highly stylized. Here, shiny metallic art deco meets Russian medieval icon painting: the glittering hoard of an art magpie.

Instead of angels hovering around the burnished saints of the Russian middle ages, we have recurring birds. They bring movement to Remnev's static people; they share the otherworldly quality of spirits. Swallows come from warmer places, bringing hope and the promise of a big thaw. Remnev's people (mainly women) are not cold, but they may be in need of warming up.

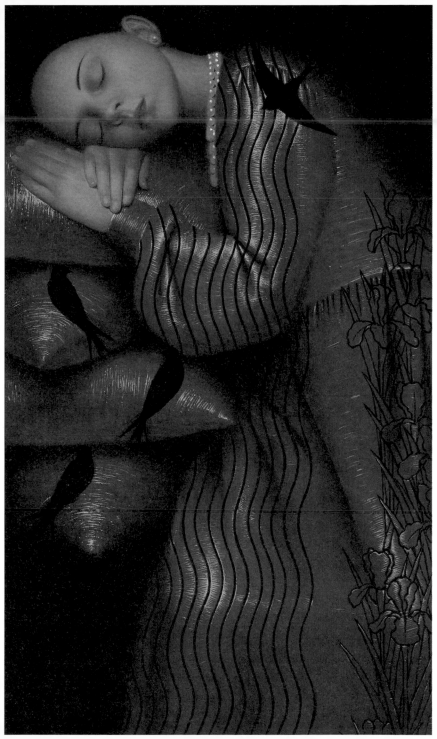

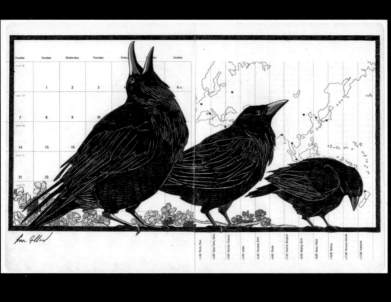

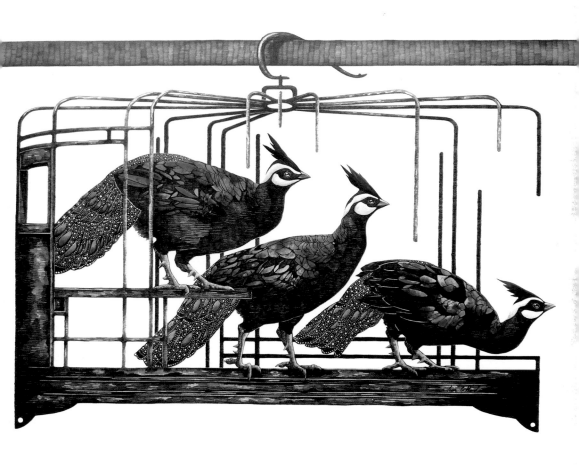

Above: Fran Giffard, *Paradis III*, 2014

Pages 78–79: Carl Wilhelm de Hamilton, *The Parliament of Birds*, late 17th or early 18th century

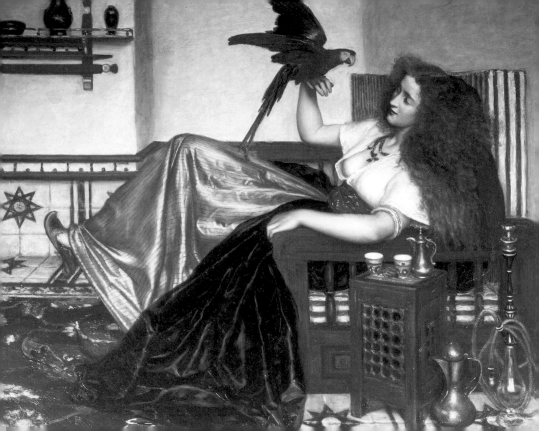

VALENTINE CAMERON PRINSEP

The Lady of the Tootni-Nameh;
or, The Legend of the Parrot

The Prinsep family was at the heart of the Victorian establishment, balancing colonial rule with bohemian ideals. With the painter George Frederic Watts, Valentine Prinsep's parents ran an informal salon from Little Holland House in West London. The Prinsep family included among its members the photographer Julia Margaret Cameron and, a generation later, Vanessa Bell and Virginia Woolf.

Watts lived with the Prinseps, having arranged the lease of the large dower house on land that is now Holland Park. The family friend did not teach regularly but he took on young Valentine, who then set off for Italy with his friends John Everett Millais and Edward Burne-Jones. Val, as he was known, did not advance beyond the status of minor Pre-Raphaelite, joining the Royal Academy with several neighbours who built their houses on the edge of the Holland estate.

Born in Calcutta, Prinsep was susceptible to the lure of the East. The *Tutinama*, or 'Tales of a Parrot', is a fourteenth-century Persian collection of stories, the main narrator of which is a parrot – a fabled storyteller in Persia as well as India. This particular bird was charged with telling his mistress amusing stories for 52 nights to keep her from other temptations.

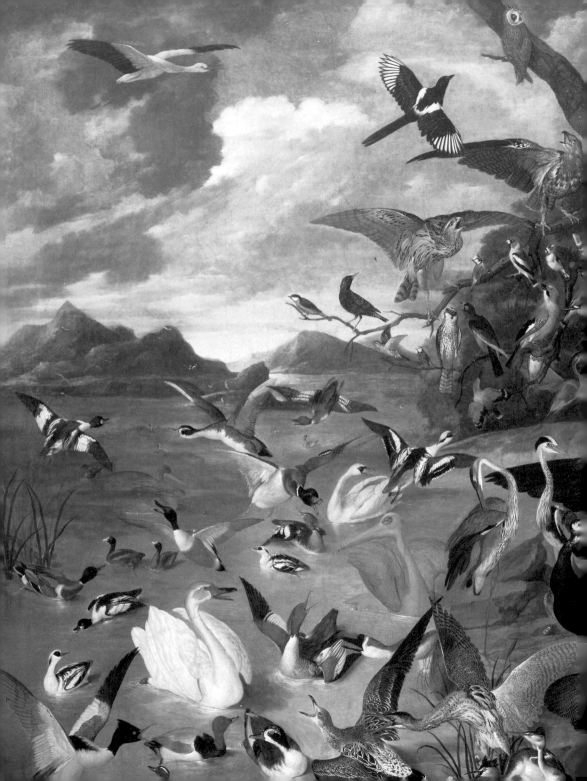

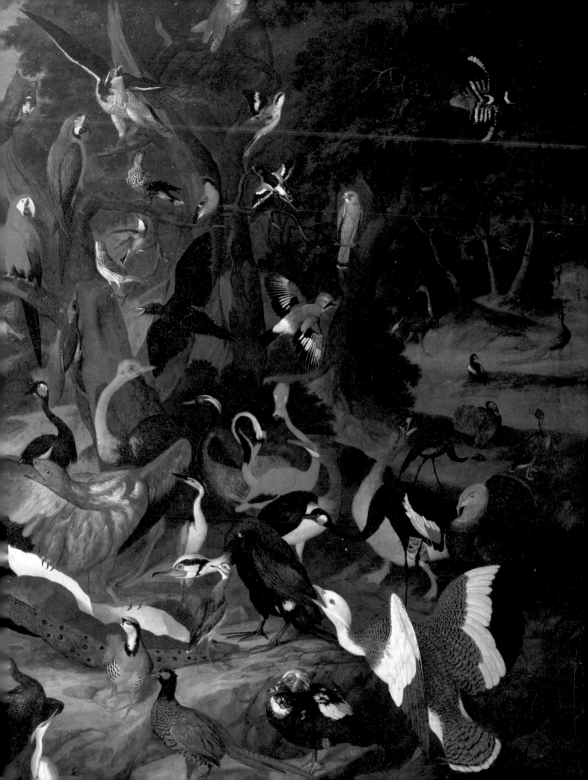

GIUSEPPE ARCIMBOLDO

Gyrfalcon

ABOUT 1575–93

It may come as a surprise that the man responsible for this dignified likeness of a superior falcon is far better known for his grotesque portraits comprised of vegetables, flowers and birds. Rediscovered by Surrealists in the early twentieth century, the strange imaginings of Giuseppe Arcimboldo clearly enjoyed great popularity, judging from his prodigious output.

But portraits of prize falcons had their place too. A gyrfalcon such as this, the largest bird in the falcon family, was an important status symbol. During the sixteenth century when Arcimboldo was keeping step with the House of Habsburg in Vienna and Prague, the rare and expensive gyrfalcon would have been seen only in the hands of nobility and royalty.

The Holy Roman Emperor Rudolph II may have allowed himself and friends to be lampooned by the Milanese Arcimboldo's *capricci*, with a peach for a cheek and a moustache of cobnuts, but his falcon? That was not a laughing matter.

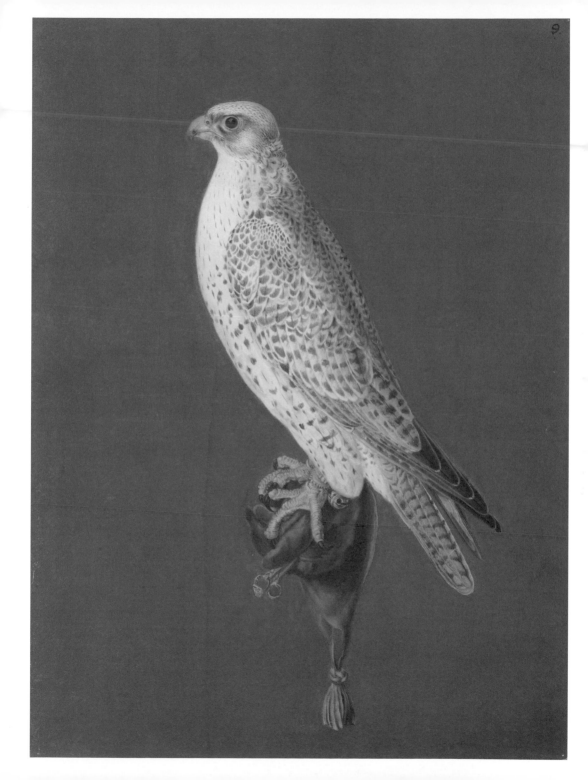

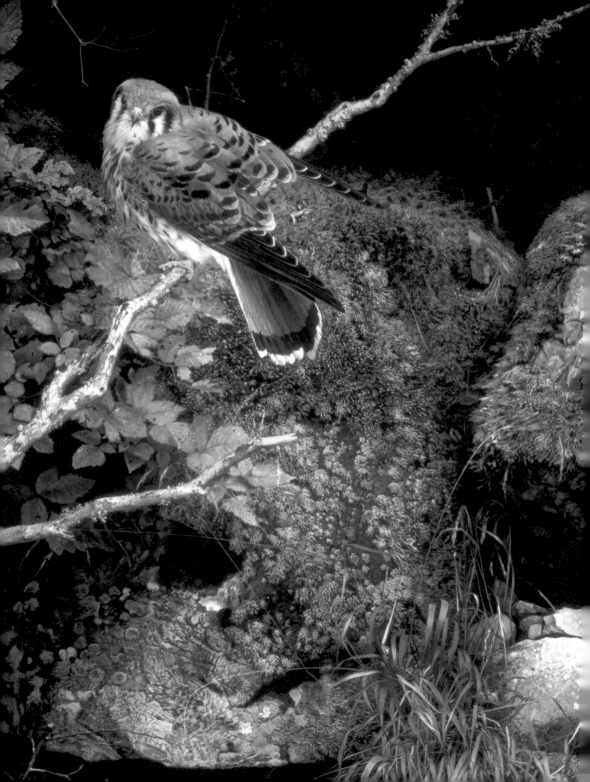

Kestrels

EAT SMALL MAMMALS,

including songbirds

THEY ARE PREY
THEMSELVES TO

HAWKS

OWLS

AND

CROWS

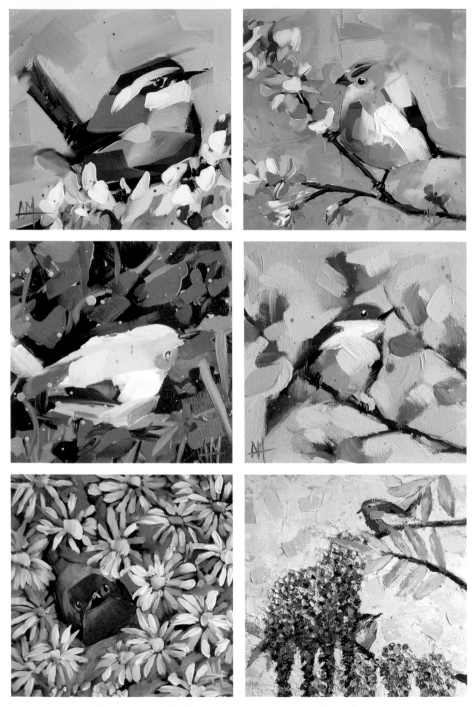

Angela Moulton, *Carolina Wren No. 29*, 11 May 2014; *Goldfinch and Almond Blossoms*, 14 January 2014;
Warbler in the Violets, 22 April 2014; *Cerulean Warbler and Pussywillow*, 23 April 2014;
Bluebird in the Daisies, 20 July 2013; *Carolina Wrens and Wisteria*, 28 September 2014

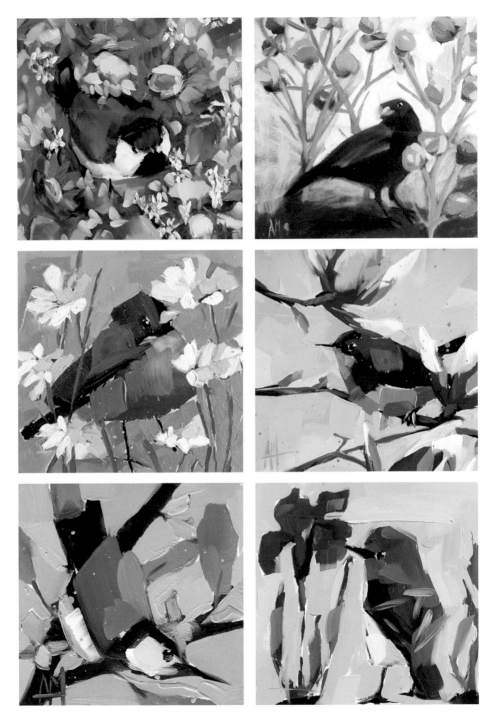

Angela Moulton, *Chickadee in the Garden*, 18 July 2013; *Crow and Purple Flowers*, 22 June 2013;
Robin in the Daisies, 28 March 2014; *Carolina Wren No. 27*, 7 May 2014;
White-Breasted Nuthatch No. 9, 2 March 2014; *Tennessee Mockingbird and Iris*, 7 September 2015

Above: Elizabeth Mayville, *Bird Head 7*, 2004

Right: Matt Adrian, *A Deep Feeling for Beauty Which Would Get Me Beaten in Certain Circles*, 2010

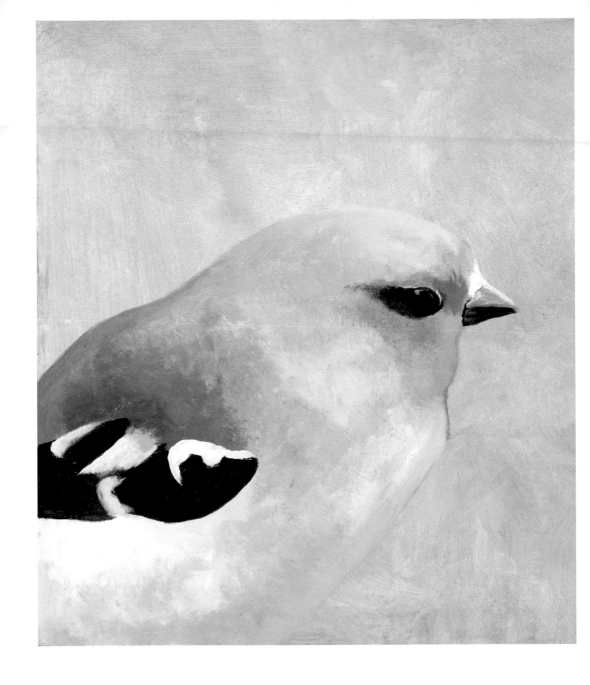

Above: Matt Adrian, *In the Poignant Moment of Finality, the Vibration of Atoms Sounds Like Singing*, 2009
Right: Matt Adrian, *Looking at Clouds as Achievable Destinations*, 2008

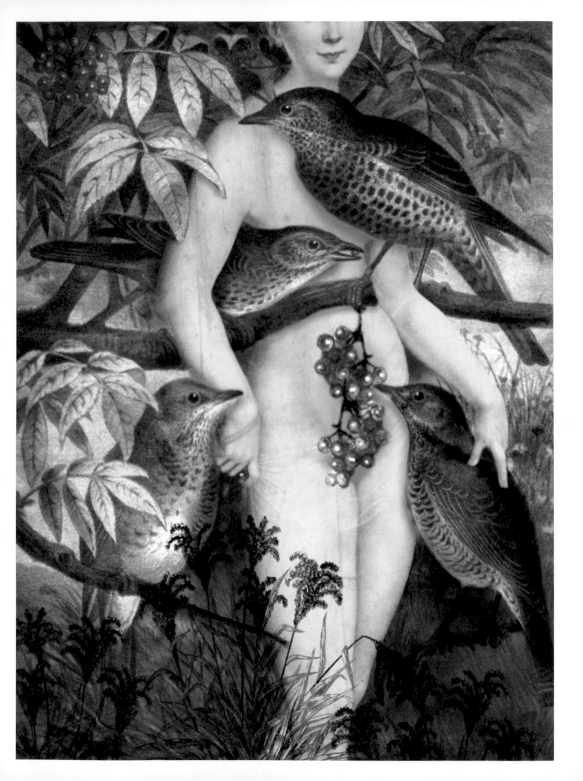

CATRIN WELZ-STEIN

Red Fruits

--- **2011** ---

Working purely with digital imagery, Catrin Welz-Stein inhabits a world of Cranach and the surreal, fairy tales and Klimt. Her collage approach to 'old' imagery is achieved through Photoshop, taking her beyond the realms of nursery-screen découpage.

The thrushes here are feasting on autumn rowan berries; the seeds within will be distributed wherever the bird happens to land. The red berries have all the mystique of mistletoe berries in winter: small jewels, held precisely in the pincer-like beak of the thrush. The larger meal of a snail, its shell whacked against stone, might be preferred, though the effect is less picturesque.

Autumn is the decadent season of abundance – no longer a buildup but the throwing off of all that has been nurtured over the previous six months. A Botticelli-style goddess, this Venus is surrounded not by flying winds and roses but feathered attendants, feasting on the season's fecundity.

ALSO KNOWN AS

'mourning birds'

FOR THEIR EERIE COOING,

turtle doves

ARE THE
MOST HUNTED
BIRDS IN AMERICA

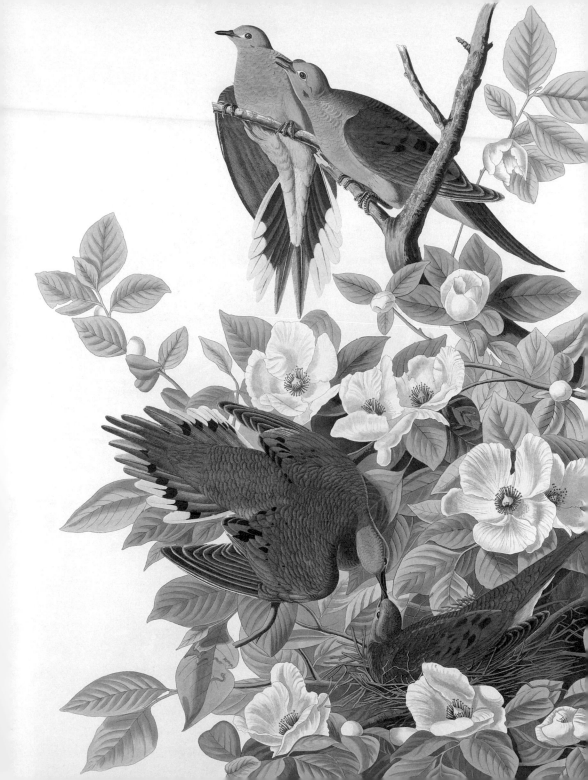

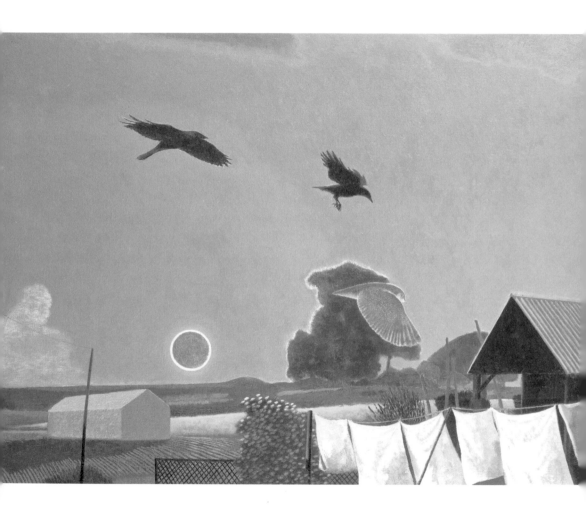

Above: David Inshaw, *A Dramatic Incident in a Wiltshire Landscape*, 1983
Right: David Inshaw, *Bonjour Mr Stockman*, 1975

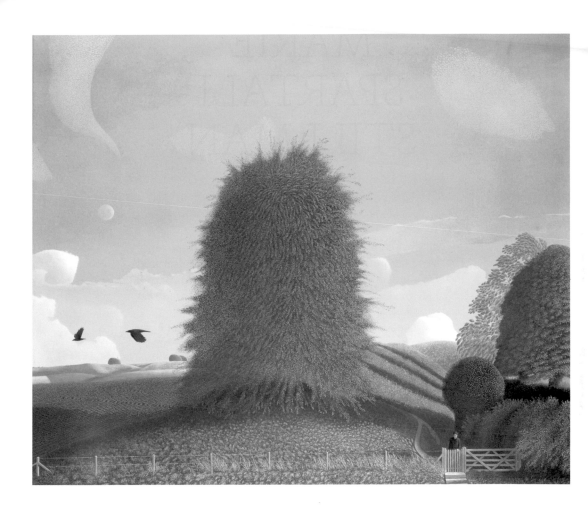

MARIE SPARTALI STILLMAN

Love's Messenger

1869

There were no women in the original Pre-Raphaelite Brotherhood – except the models, of course, who featured heavily, both domestically and on canvas. Marie Spartali Stillman was not as easily categorized, being both a great beauty as well as a painter.

Stillman's Anglo-Greek looks had drawn attention early on; she appeared as Desdemona for Rossetti and as a variety of goddesses for Julia Margaret Cameron. Here we see a Pre-Raphaelite 'stunner' with a look of determination. Stillman trained as a painter under Ford Maddox Brown (who also taught Rossetti) and later lived in Italy with her husband, who was foreign correspondent for the *Times*. She was perfectly placed geographically to continue the classical references in her own work.

The dove here is purely symbolic, a favourite bird of Venus; the girl wears a rose, symbol of love. How different from Rossetti's dove in *Beata Beatrix*, clutching the gloomy portent of an opium poppy.

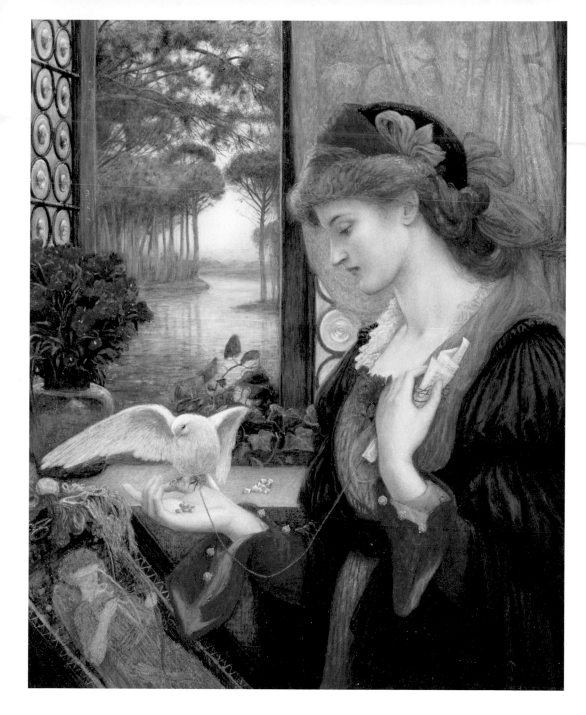

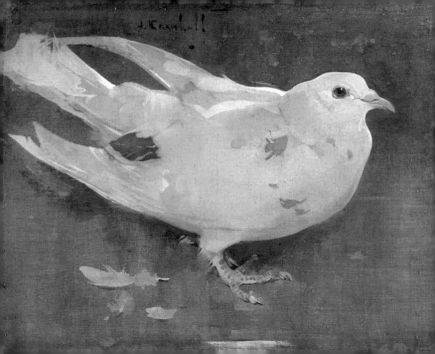

A FLOCK OF
WHITE DOVES RELEASED
INTO THE AIR
IS REALLY A FLOCK OF

white pigeons

LIKE THIS ONE.

White doves
would not be able to
find their way home

Joseph Crawhall, *The Pigeon*, about 1894

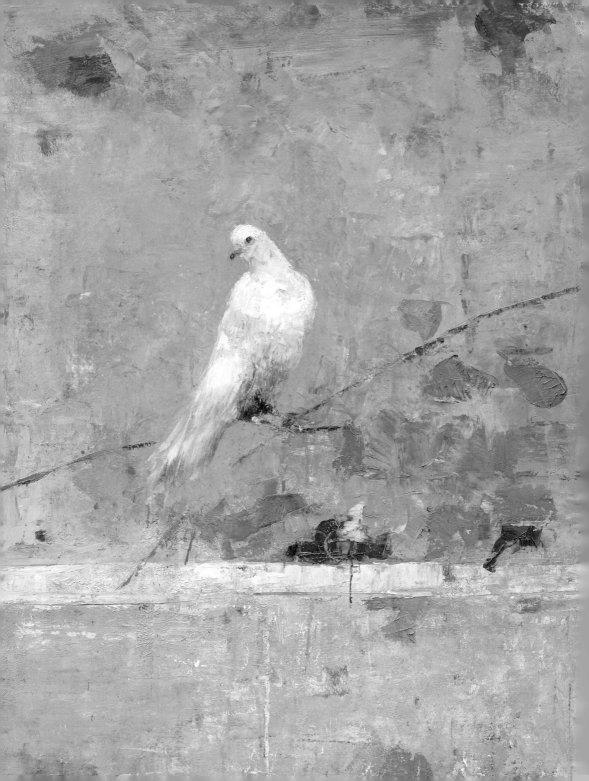

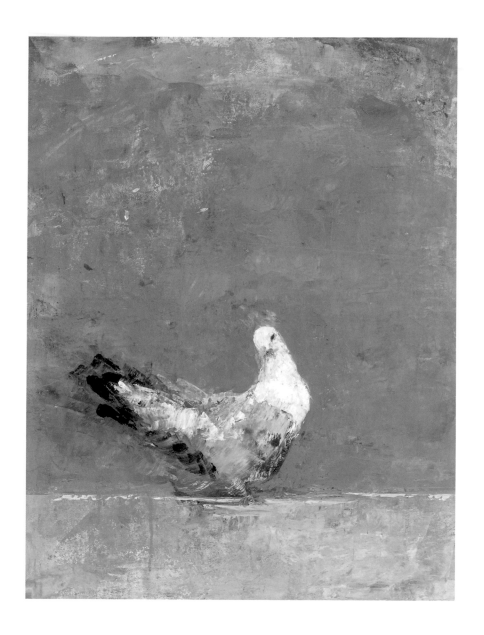

Left: Goxwa Borg, *Bird on Vine*, 2012
Above: Goxwa Borg, *The Proud Pigeon*, 2011
Pages 104–5: Yuko Shimizu, *June 12, 1967,* 2010

RENÉ MAGRITTE

Man in a Bowler Hat

———————————— **1964** ————————————

Magritte's works have long been ingrained in our consciousness: the suit, the pipe, the bowler hat. Sometimes there is an apple in front of the man's face; sometimes there is a dove. The original apple painting dates from 1946, the dove painting from 1964. Similar arrangements, transposed objects. Are the dates a joke as well?

Magritte, a commercial painter from Belgium whose deadpan style was to influence Warhol and Pop in general, had early success with Surrealism, and by the 1960s he was again appreciated. He found his themes and stuck to them, suggesting the unusual in the usual. He shared with Warhol a love of repetition and was criticized for it, but the instantly recognizable style of each is used constantly as shorthand for graphic artists everywhere.

The hatted gent is Magritte, as well as every bourgeois icon from Steed in *The Avengers* to Monsieur Hulot. The dove may have had as much to do with its graphic appeal as its symbolism. More refined than a street pigeon, less raucous than a parrot, the dove on the wing keeps things light, serene, unusual.

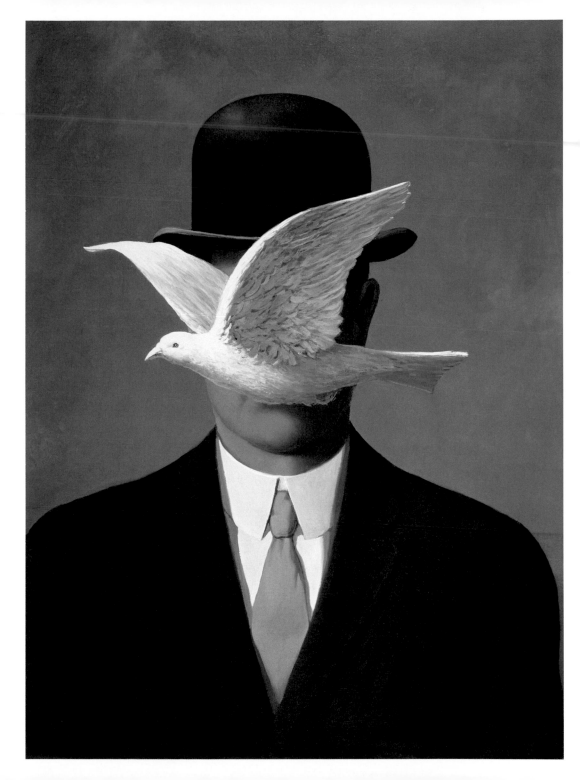

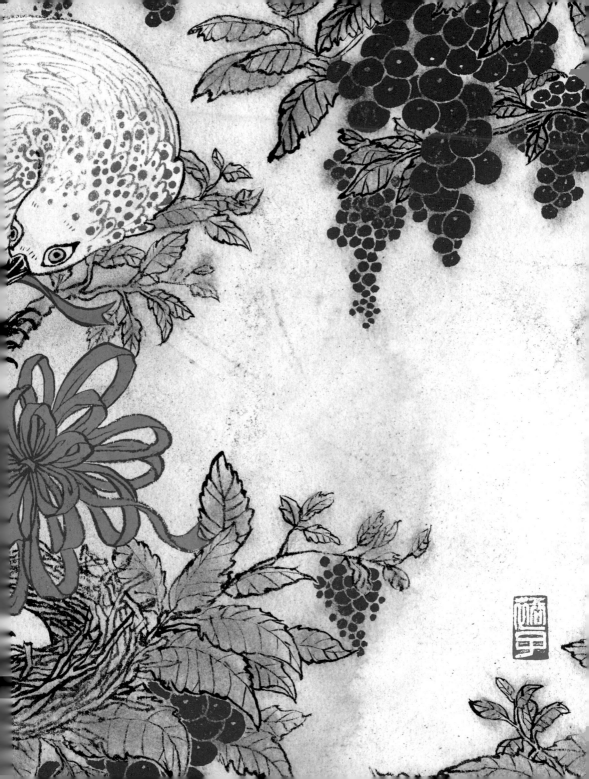

ARE OWLS ESPECIALLY
INTELLIGENT?

IT'S CERTAINLY MORE

clever

TO BE AN

eagle owl

WHICH SITS AT THE

TOP

OF THE FOOD CHAIN,
WITH NO
REGULAR PREDATORS

Sarah Esteje, *Le Grand Duc (The Grand Duke)*, 2011

WILLIAM JAMES WEBBE

The White Owl

1856

White barn owls fly by night; they are not interested in dawn or dusk. Their nocturnal habits have pushed them into the realm of malevolence in our folklore: ghost owl, death owl, the bird of doom. These are the names we have burdened them with.

The sharp beak and talons of this white owl will have done their deed before this mouse is eaten whole. The painting's subtitle – 'Alone and warming his five wits, / The white owl in the belfry sits' – is taken from Tennyson's poem *The Owl*, in which cats wend their way home and 'merry milkmaids click on the latch'. In other words, it is dawn. With eyes closed, the owl rests his other four senses in the shelter and relative warmth of the church.

When the painting was shown at the Royal Academy in 1856, William James Webbe was praised by boisterous critic John Ruskin: 'The brown wing is excellent.' With a small caveat: 'But I think the breast might have been nearer the mark.'

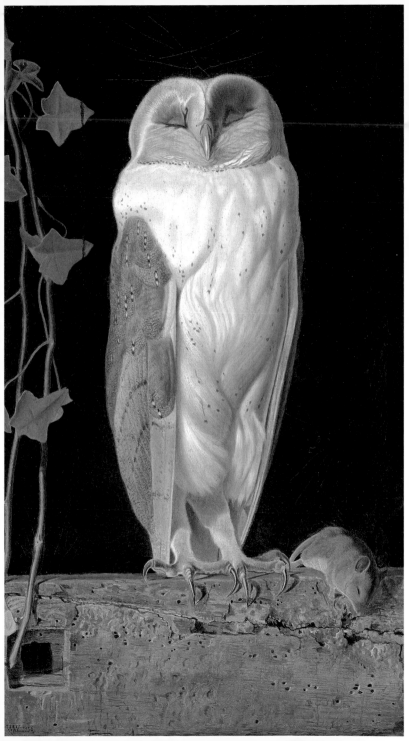

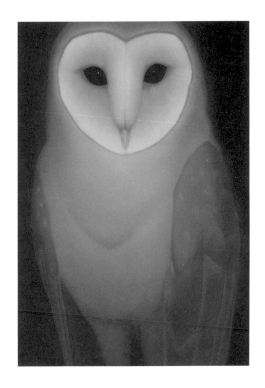

Left: Peter Vos, *Untitled*, 2007
Above: Peter Vos, *Untitled*, 2007

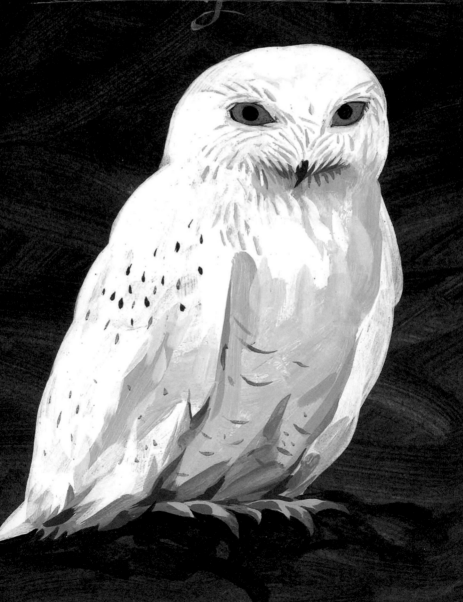

Snowy Owl

Left: Jeffrey Fisher, *Snowy Owl*, 2009
Above: Jeffrey Fisher, *Robin*, 2009

A

MURMURATION

OF

starlings

IS MADE OF

hundreds of thousands

OF INDIVIDUALS,

BLACKENING
THE SKY

DURING MIGRATION

Predators are as
bewildered as we are

Right: Sarah Esteje, *European Starling*, 2014
Following spread: Susan Homer, *Blue to Blue*, 2013

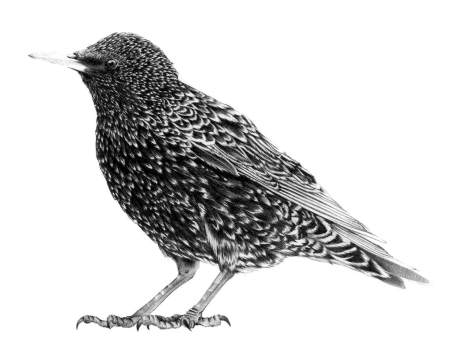

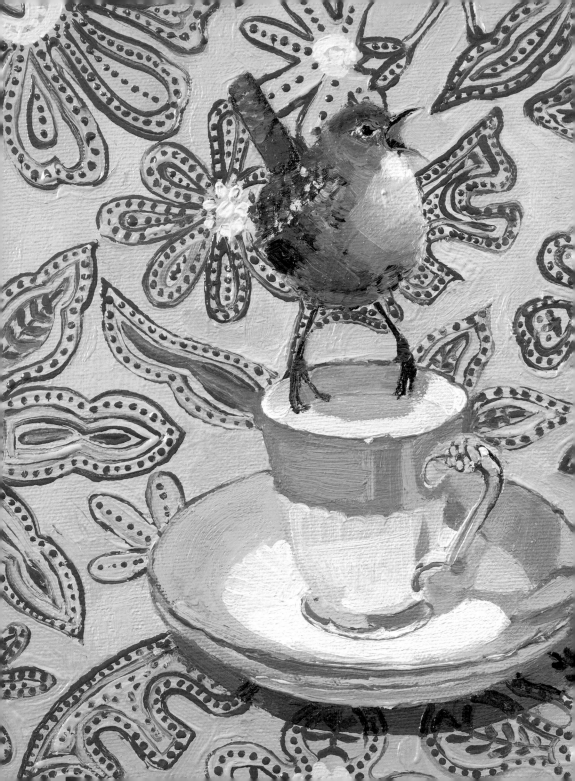

Wake early and start drawing. Have coffee and toast.
The weather is strange : windy and cool. Continue drawing
and have lunch. My interview with the *Royal Gazette*
is published. Jessie has written as well and I feel elated
all day.
Andrew Dobson comes over to say hello and to see my
birds. After our chat, David and I go for our walk.
There are lots of cyclists about. We watch some of
their timed challenges. I bump into Mark Norman,
who organised my Outward Bound adventures, including
my Duke of Edinborough Gold, with his daughter and
Conrad who finished the Gold expedition with me.
I ... here. It is fun to run into old friends.

Mum!
Drew her a sea bird.

Wake up to coffee, breakfast and sunshine. Jump on
a bus to Hamilton and see Norma and Phil for the first
time in two years! It feels like no time has passed. We have
cake from the Portuguese Bakery with tea. Frances ...
knew that Masterworks have collected every... they
all look fantastic! Mum and I make sandwiches and we
all drive to Warwick Long Bay. The sea is ... and
I have the best time. After a sea ... the parrot fish
we all go home. ... we drink almost
too much ... have a lovely
evening ... made brownies.
David ...
SL...

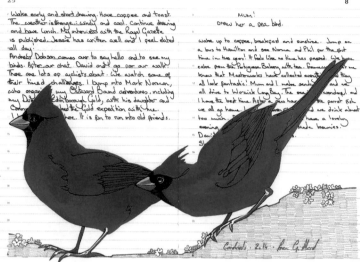

Cardinals, 2014. Fran Giffard

destination / itinerary	date	essential bibliography / notes
Bermuda	11. 13. 2014	Gatwick North Terminal BA 2233
Return to London (land)	10. 6. 2014	Gatwick - BA 2232
	11. 6. 2014	WEDNESDAY.

Ga... I land.

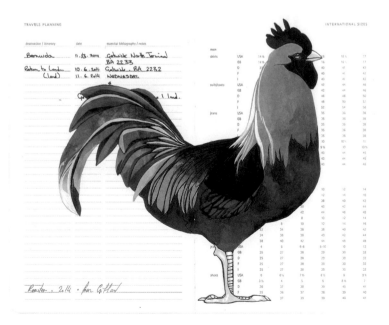

Rooster. 2014 · Fran Giffard

Top: Fran Giffard, *Cardinals*, 2014
Above: Fran Giffard, *Rooster*, 2014

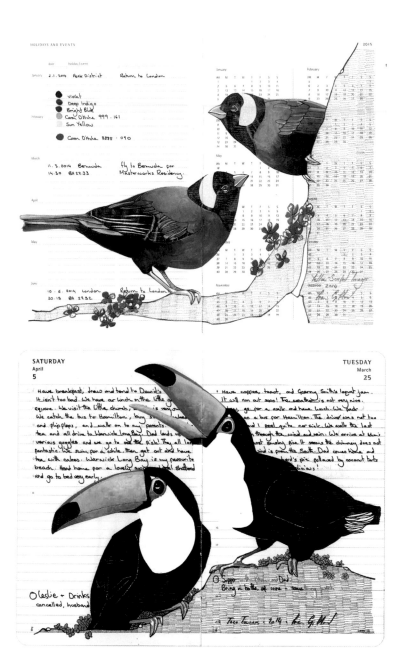

Top: Fran Giffard, *Yellow-Scarfed Tanager*, 2014
Above: Fran Giffard, *Toco Toucan*, 2014

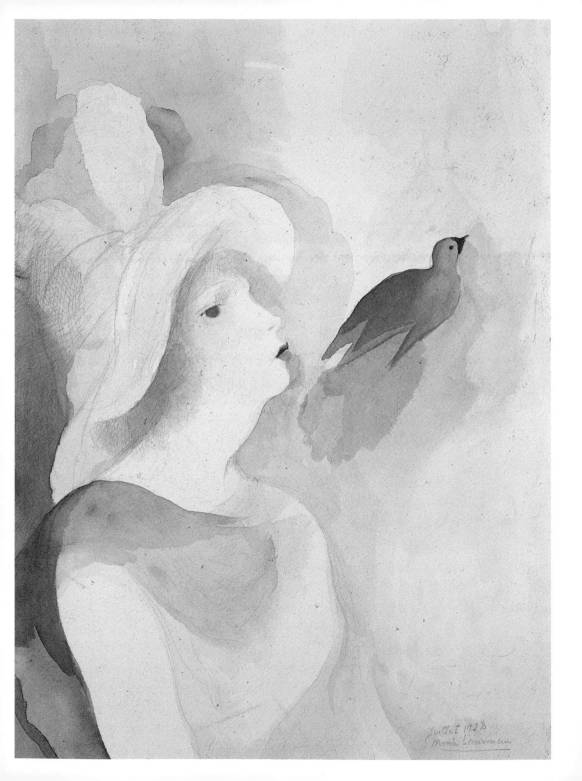

MARIE LAURENCIN

Jeune Fille à l'Oiseau Bleu (The Blue Bird)

—— **1928** ——

Marie Laurencin painted this in 1928 after she had already lived several lives, first as a Cubist painter and muse to the poet Apollinaire in Paris, then lying low during the Great War in Spain. She returned to Paris in the 1920s, developing a new style which tended to involve dark-eyed heroines with animals. She also worked as an illustrator and set designer, commissioned by Sergei Diaghilev for his ballet *Les Biches.*

During this period as a set designer, Laurencin met Coco Chanel, who was designing Diaghilev's costumes. A portrait commission followed but it did not end well; Chanel complained that the result was not a good likeness. The painting was dominated by lively dogs as well as a dove, its beak taking aim at the great lady's neck.

Here we are on safer territory. The girl may be a well-to-do client but her interaction with the blue bird is pure and gentle; the only strong tones come from the key elements of lips, eyes and bird. Resembling a dove in shape, the bird's colour hints at the fairy tale *The Blue Bird.*

Above: Matt Adrian, *The Princess and the Potty Mouth*, 2012
Right: Matt Adrian, *Voyages of Discovery I Wish to God I Had Not Undertaken*, 2011

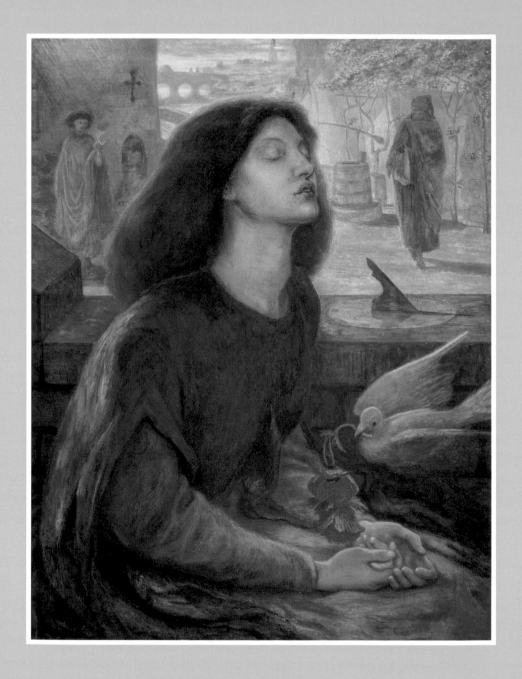

DANTE GABRIEL ROSSETTI

Beata Beatrix

1877

With a name in common, Dante Gabriel Rossetti's sympathy with the Italian poet Dante Alighieri ran deep. Besides finding fame as a painter, poet and co-founder of the Pre-Raphaelite Brotherhood, Rossetti was a translator, and published his own version of Dante's poem *Vita Nuova*. In *Beata Beatrix* ('Blessed Beatrice'), a story of obsessional love and loss, Rossetti features Dante's Beatrice in the form of Lizzie Siddal, Rossetti's wife and muse, recently deceased from a laudanum overdose.

Beata Beatrix was painted and drawn several times. In the first version, the poppy was white, and the dove, a portent of death, passionate red. In this later painting, there is less anguish in the face of Beatrice/Lizzie, and the dove's benign status has been restored, red transferred to the opium poppy. Ford Maddox Brown finished the painting after Rossetti's own death, after a long addiction to chloral hydrate, washed down with quantities of whiskey.

Above: Charming Baker, *A Fall to Alms*, 2014
Right: Charming Baker, *Bird III*, 2013

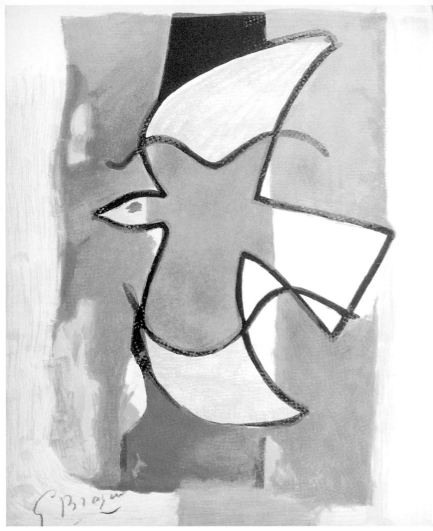

GEORGES BRAQUE

L'Oiseau Bleu et Gris
(*The Blue and Grey Bird*)

— 1962 —

Georges Braque painted his studio again and again; in the pictures – a series titled *Atelier* – the chaos of a semi-reclusive artist's studio is dominated by a soaring bird. Though paintings of a painting of a bird, the outstretched wings and peaceful expression give a sense of movement and creative freedom to the static workplace.

Braque's birds bring to mind those of Matisse, with their flowing shapes and two-dimensional vitality. Yet Braque is best remembered for his early collaboration with Picasso, co-founder of Cubism during the years before the First World War. Unlike Picasso, he continued to explore Cubist ideas throughout his career.

In the last decade of his life, Braque was asked to decorate a ceiling of the Louvre in Paris. His giant birds float over the Etruscan gallery, their painted sky framed by wood carvings from 1557. The blue and grey bird here was part of a book of lithographs made when Braque was 80. The same year saw the publication of *L'Ordre des Oiseaux* (*The Order of Birds*), written by the poet Saint-John Perse and illustrated by Braque – a meditation on birds, Braque and Braque's birds.

Gulls

WERE THE FIRST OF OUR

FEATHERED
FRIENDS

to turn nasty in
Alfred Hitchcock's
The Birds

BILL BRANDT

Early Morning on the Thames, London

1939

Early Morning on the Thames captures a moment in the life of the East End of London, during the last summer of peace. The photograph of the serene gull, gliding between moon and docks, is all the more remarkable when seen in the context of the time.

Although Bill Brandt is considered to be one of the giants of twentieth-century photography – straddling documentary portraiture as well as art – he earned his living via the pictorial magazines, moving among the English as a discreet voyeur. German-born and Paris-trained, he carried a Rolleiflex, enabling him to take photographs from the hip, little noticed.

The seagull was part of an essay for a picture weekly by the name of *Lilliput*, in 1939. Brandt's pictures of contemporary London ran alongside engravings by Gustave Doré, another non-native observer, who had caused a stir with his studies of the far reaches of city life, seventy years before. *Lilliput*'s essay was titled 'Unchanging London' at a time when everything, besides the presence of seagulls, was about to change forever.

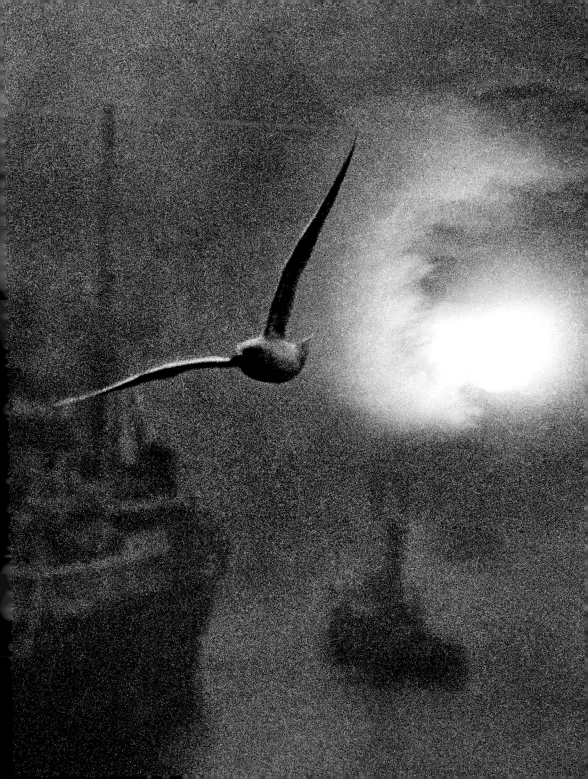

Ryohei Tanaka, *Snow – Crow*, 2008

Eric Hynynen, *Strange Fruit*, 2012

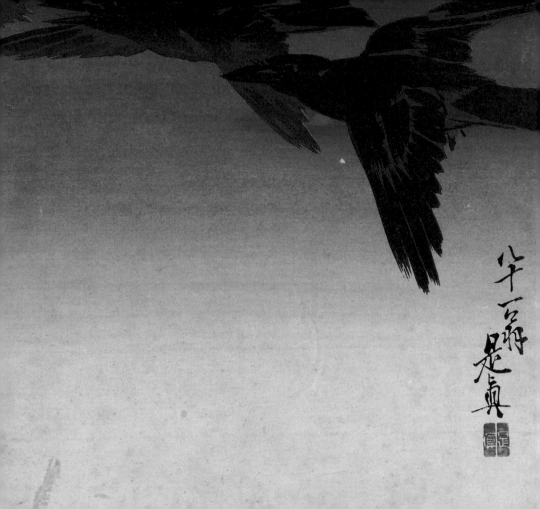

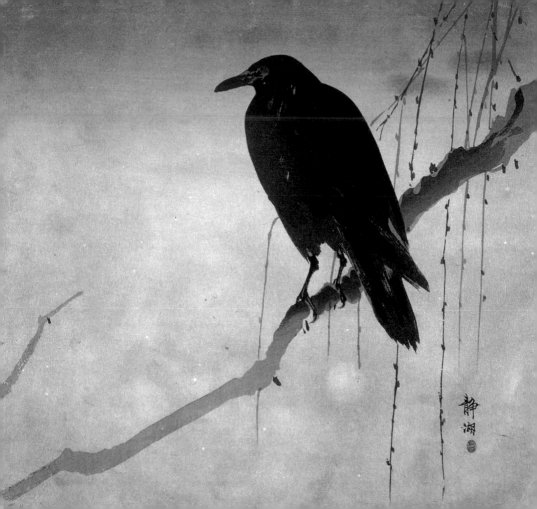

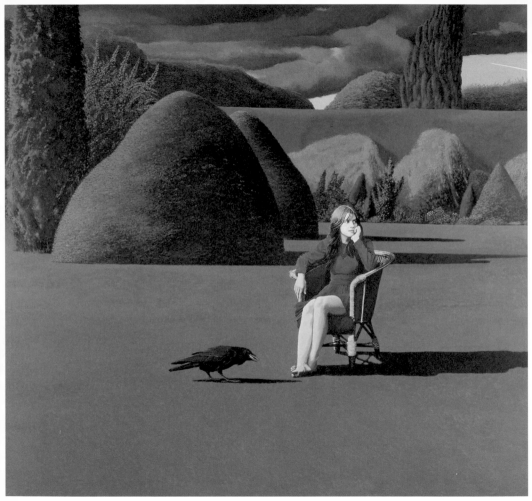

DAVID INSHAW

The Raven

When David Inshaw first moved to the West Country, he was given a copy of *Tess of the D'Urbervilles* by a girlfriend and fell in love with its heroine. His landscapes became emotional, magical and mysterious; this one shares its title with the deathless poem by Edgar Allan Poe. Like Poe's avian protagonist, this raven might just talk.

The slanting light, throwing long shadows over the carpet of lawn and highlighting the giant shrubs, says one thing: downpour. The raven inches toward the girl with its own dark message. The girl herself was linked romantically with her portraitist; this is her first appearance in a series of ambiguous, uneasy paintings, and things did not improve. She looks anxious.

Four years after *The Raven*, Inshaw set up the Brotherhood of Ruralists (with male and female members) after Peter Blake moved to Somerset with Jann Haworth. Of the West Country group Blake has said, 'We admire Samuel Palmer, Stanley Spencer, Thomas Hardy, Elgar, cricket, the English landscape and the Pre-Raphaelites.' Like the Pre-Raphaelite Brotherhood, they set their sights on a radically atavistic pastoral tradition.

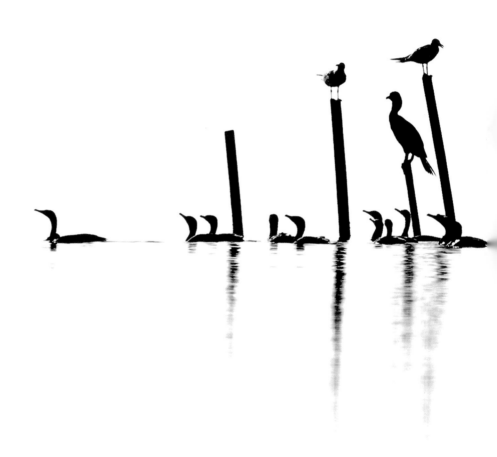

Constance Mier, *Gulls and Cormorants 1*, 20 August 2009

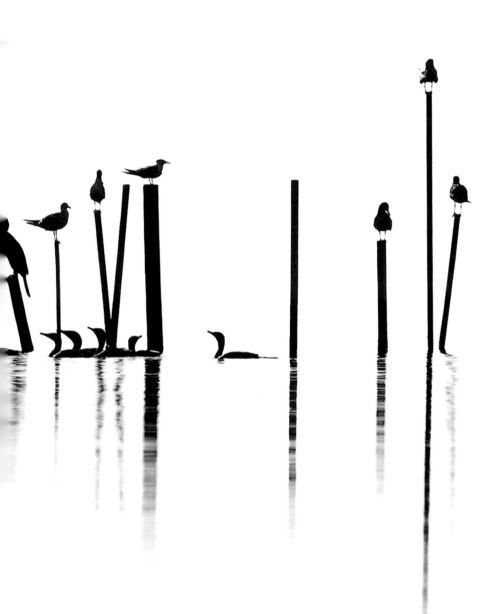

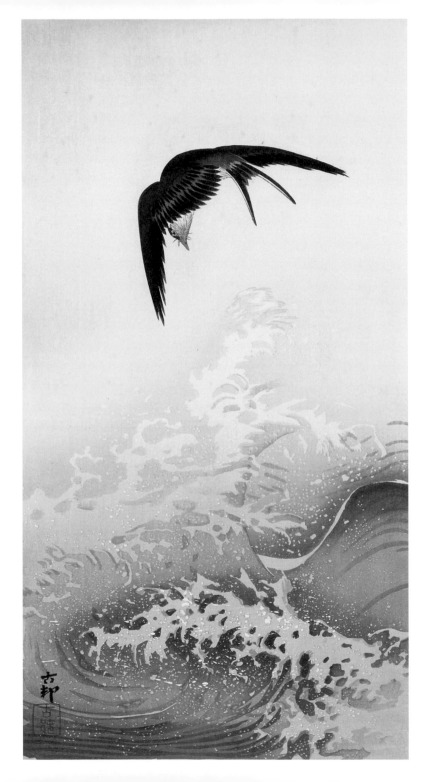

OHARA KOSON

Swallow over the Ocean Wave

Japanese aesthetics had long been admired in the West before the Japanese in turn began to borrow back. The *Shin-Hanga* movement in the pre-war years of the twentieth century integrated elements of Western art while retaining Japanese woodblock-printing traditions. The results were mainly exported to the West; when the movement was reappraised later in the twentieth century, examples had to be bought outside of Japan. The 'new print' style had been rather looked down on at home.

Traditional Japanese subjects of birds and flowers, known as *kacho-e*, were blended with more vibrant colours and an element of Western realism, making the *Shin-Hanga* movement exciting to a Western audience. This new rendering of animals and pictorial composition clearly continued to influence the West, even down to Disney's *Silly Symphonies*. The cultural exchange closed down with the rise of militarism before World War Two.

Meanwhile, the swallow, associated with migration in both cultures, keeps on flying over that ocean to warmer climes.

Above: Hector Giacomelli, *Flying Nestward*, 1891
Right: Arthur Oxenham, *Migration of Swallows*, about 1966

PARTNERS
FOR
LIFE

goshawk couples

BUILD THEIR
UNWIELDY NESTS IN
OLD WOODLAND

They avoid the neighbours
by nesting at least
one kilometre apart

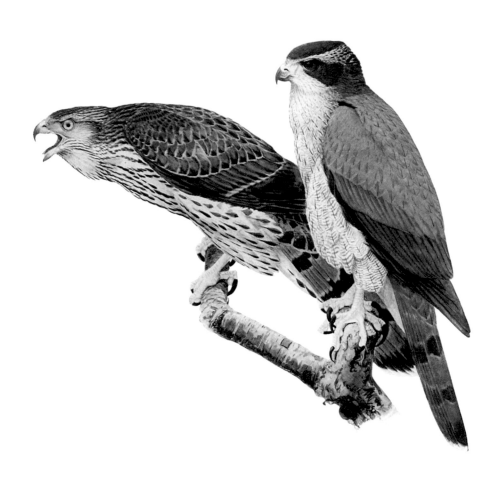

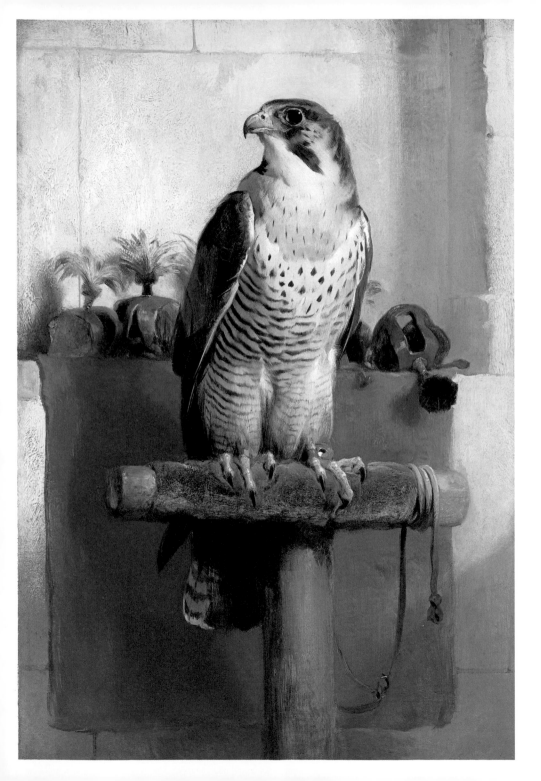

SIR EDWIN LANDSEER

Falcon

1837

We think of him as the ultimate Victorian, his animal paintings collected by royalty, his lion sculptures still drawing the tourists on Trafalgar Square. From childhood the future Sir Edwin Landseer had the outstanding talent to take him to early Victorian eminence, first exhibiting at the Royal Academy at the age of 13.

Landseer's paintings were universally popular; even critics were generally enthusiastic. Mild complaints of sentimentality were the exception to the rule. To us, it is hard to imagine a young man producing animal paintings with titles like *There's No Place Like Home* or *Dignity and Impudence*; there are some elements of Victorian culture which still don't translate.

Falcon was painted when Landseer and Queen Victoria were both young, around the time that she became a key patron. In terms of animal anatomy, Landseer is unassailable. Exquisite in its detail, from the tufty hoods to the bell on the bird's foot, this is not a genre picture but a record of power and rank.

Christine Berrie, selection from *Bird Bingo*, 2012

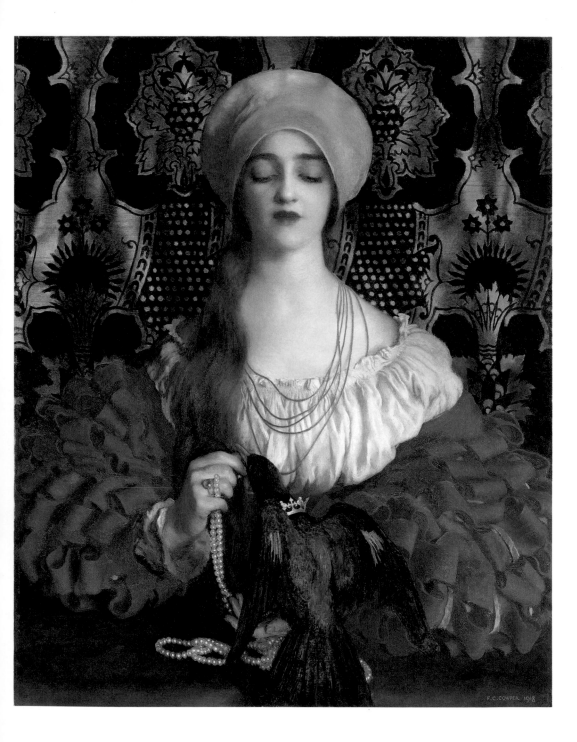

FRANK CADOGAN COWPER

The Blue Bird

1918

In art, the relationship between birds and people is almost always about birds and women – and rarely about *just* birds and women. This uncommon blue-feathered creature is a prince, and the luxuriously imprisoned young female is a princess. The crown on his collar is a sign of his rank, but if we are familiar with the fairy tale *The Blue Bird*, from which this scene is taken, we know that this odd couple will be united one day, as people. For the purpose of visiting a locked-up princess, being turned into a bird by a fairy has its advantages.

Frank Cadogan Cowper's Renaissance-influenced paintings are particularly suited to portraying imprisonment, with their confined spaces and shallow planes. A latecomer to the Pre-Raphaelite scene, Cowper had had to switch to formal portraiture as a source of income, though it was clear that his heart lay in subject pictures. He was still showing the latter, in an increasingly achronistic style, at the Royal Academy in London in the 1950s.

PLOVERS

ARE LESS FETED THAN THEIR

eggs

ONCE FAVOURED AS

a delicacy

BUT NOW PROTECTED

Amy Veldman-Wilson, *Black-Bellied Plovers*, 2014

THE
little egret
IS NATIVE TO
THE MEDITERRANEAN,
WHERE TIME
DOES NOT
ALWAYS FLY

Kevin Sloan, *The Persistence of Memories*, 2011

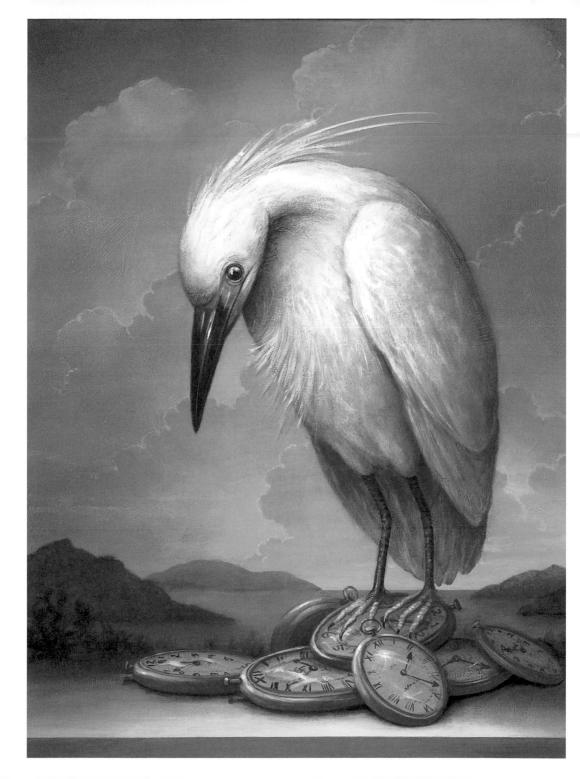

Matt Adrian, *It Had Seemed Such Innocent Pleasure*, 2011